MURDER

in

LINN COUNTY

OREGON

The True Story of

THE LEGENDARY PLAINVIEW KILLINGS

CORY FRYE

THE
History
PRESS

Published by The History Press
Charleston, SC
www.historypress.net

Copyright © 2016 by Cory Frye
All rights reserved

Cover: "Ghosts of Plainview," Mark Ylen, *Albany Democrat-Herald*, 2014.

First published 2016

Manufactured in the United States

ISBN 978.1.46713.522.1

Library of Congress Control Number: 2016932069

CONTENTS

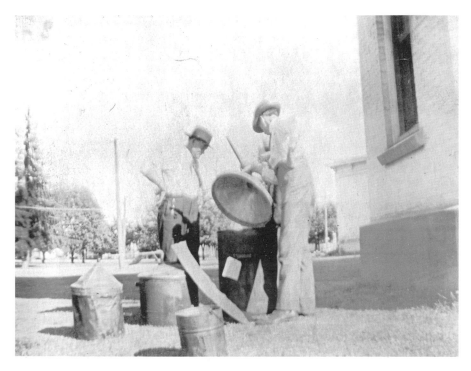

Linn County sheriff C.M. Kendall (right) and his crew dissemble stills in the early 1920s.
Courtesy of Judy and Terry Broughton.

ACKNOWLEDGEMENTS

I couldn't have embarked on this three-year odyssey without the indulgence, abetting and encouragement of at least the following: Addie Maguire and the Albany Regional Museum, my home away from home, often swarming with the harmonies of Crosby, Stills & Nash as I labored over century-old documents (and which generously authorized use of historic photographs); journalism colleague and friend Susan Bodman, whose harrowing trudge through the *Salem Statesman-Journal* morgue helped me track Ada Healy into the 1980s; Steve Druckenmiller and the staff at the Linn County Courthouse, who didn't seem to mind the overexcited man-child exulting over dust; Oregon Historical County Records, for obvious reasons; the Linn County Genealogical Society at the Albany Public Library, perennially shocked that I knew my way around (it's a small room, people!); the Linn County Sheriff's Office, of course; the almighty Paula Martin, who took a keen interest in Russell Hecker and plucked fact-bouquets from databases unknown; Dinee Alexy, whose counsel kept me from binning the manuscript in frustration; various editors, specifically Rachel Beck and Nancy Raskauskas-Coons, who kept that red ink wet, slashing bloviation into a leaner beast; retired Linn County sheriff Art Martinak, who helped me understand what it meant to be a lawman in the '20s; David Sullivan, the current owner of Clark Kendall's final residence; the Linn County Historical Museum in Brownsville; the East Linn Museum in Sweet Home; the *Albany Democrat-Herald*, which green-lit a Sheriff Kendall test run in the final Sunday edition of 2014; staff photographer Mark Ylen, who accompanied me into

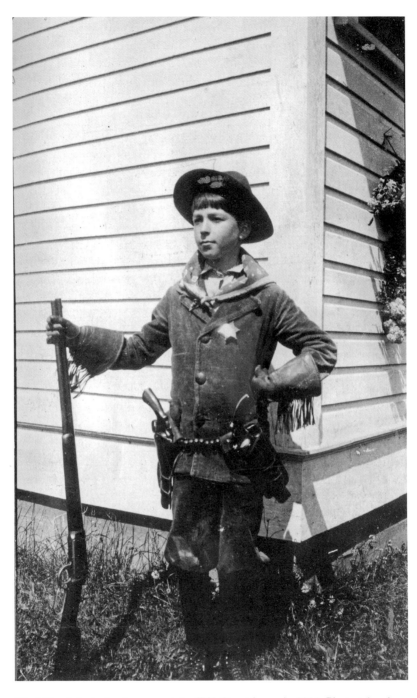

Clark Kendall playing lawman at the Fifth Street house in 1914. Photo taken by Estella Kendall. *Courtesy of Judy and Terry Broughton.*

Shedd (i.e., Plainview) one dreary December morn and, with Jesse Skoubo, took most of the contemporary photos featured here; Amazon.com, which helped me locate and purchase copies of Cloy Sloat's long-out-of-print *Sunset Valley*—I read it so you didn't have to—and, somehow, the November 1924 issue of *Woman's Home Companion*; Allen Parker, whose family has owned most of the former Dave West property for seventy-plus years; Wendell Manning, who offered rich context on Plainview through his grandfather's stories; Danny Young, who now lives on the West land and allowed two interlopers to slosh about, taking pictures and notes; *This American Life*'s "The Ghost of Bobby Dunbar," which I listened to every night as I fell asleep; and Christen Thompson and the folks at The History Press, who read my pitch and handled my late-game panic with aplomb.

Truthfully, however, none of this was possible without the participation of the families involved. Carla Healy offered her time, knowledge and genealogy. In fact, she was the first living person with whom I spoke, a year into research, a revelation she found amusing. Gary and Ingrid Margason graciously provided the only known photo of Dave West, the man Gary's grandmother called her brother, and were nothing but kind to me. Terry, Judy and Joy Broughton were the project's true champions—without their preservation of the Kendall family's archives (hundreds of letters, documents, photos and ephemera), *Murder in Linn County, Oregon* couldn't exist at all, in any form. At my side, literally, through most of it: the ever-patient Michelle Jory, weathering my obsessive, sometimes futile pursuit of ghosts, real and imagined.

I dedicate this to the boys in blue, particularly my late great-uncle Lowell, an old-school Albany cop with a gruff manner but a great sense of humor—a Frye to the marrow.

Also, Clark Kendall, wherever you are: this one's for you.

THE FINAL MORNING, 1922

Sheriff Charles Kendall met the day alone. His wife was up north, visiting a sister, taking in the palette of the Portland Rose Festival. Their only son joined her, enjoying his first summer after his freshman year at Albany College.

Sheriff Charles Kendall met the day alone. But that was fine. He had plenty to keep him busy: multiple warrants to serve for violations of the

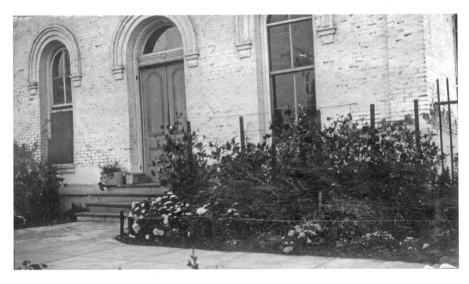

The Linn County jail exterior in the early 1920s. Photo taken by Estella Kendall. *Courtesy of Judy and Terry Broughton.*

Volstead Act, that notorious law that spawned Prohibition and, according to Brownsville's Good Citizenship League, had birthed a menace across Linn County. In fact, he and county district attorney L. Guy Lewelling had conferred with this coalition only a week earlier to discuss this very issue. Now Kendall was making good, demonstrating a willingness to make a statement.

Sheriff Charles Kendall met the day alone. Affixed and straightened his badge. Patted it down, pulled his jacket tight. Filed his warrants into an inside pocket. Topped his head with a hat, straightened it into place. Left the quarters he shared with his family above the Linn County jail. Closed the door behind him.

Sheriff Charles Kendall met the day alone. So no one heard him as his footfalls met the stairs, echoing, fading, never to return.

THE MINISTER

The ghosts of the past have not all betaken themselves to the otherwhere.[1]

Near the end of December 1921, the Reverend Daniel Poling sat in his Corvallis home, corralling observations for the coming year. The kind-eyed fifty-six-year-old led Albany's Presbyterians, but this weekend his canvas was larger: the Sunday edition of the *Albany Democrat*. Charles Alexander oversaw the paper on those days—a good fellow, a printer and novelist who on the Sabbath mixed sober reportage with languid perusals, promoting and feeding Linn County's literary ambitions.

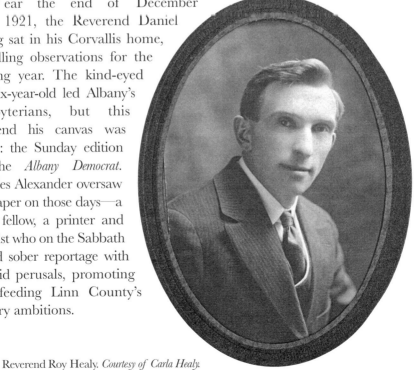

Reverend Roy Healy. *Courtesy of Carla Healy.*

"Tomorrow I shall step across the threshold of 1922," he wrote, "and I ask for courage to march straight into it, and its experience...I pray thus for myself in the year 1922. I pray for my friends unto the uttermost borders of the world. May this be a 'year of the Lord,' a prosperous, happy, progressive year."[2]

Initial signs pointed toward abundance. As Poling's pronouncements went to press, Roy Healy, his brother in Christ, met with the board of his First Christian Church. The gathering's tone was celebratory. A basket lunch topped the agenda, followed by an encouraging dessert: 1921's final numbers, the best the church had ever known. Increases abounded in every department. Some 104 new faces had filled the pews, and collectively the congregation had raised more than $9,000 against expenses. Not bad for Healy's first full year. He'd proven a godsend, and the assemblage expressed confidence that the new year would build on the old.[3]

Roy Healy seemed destined to answer "The Call," entering the world on Christmas Day 1886 in the nearby town of Lebanon (not exactly Bethlehem but quaint and charming).[4] Yet he'd traveled well in his thirty-five years, ministering from the Willamette Valley to the upper reaches of the Pacific Northwest and then down through Northern California before returning once more to his native soil and to this twin-towered temple at the corner of Fourth and Broadalbin.

Hardship, naturally, moved with blessing. His birth mother, Emma, would never know of his godly achievements, would never watch with pride as Roy and his older brother, Leonard—whom many knew affectionately by his middle name, Bert—matured into upstanding men. She died in February 1898, when Roy was twelve and Bert fourteen, lain to rest in Lebanon's IOOF Cemetery, where her headstone, pristine as the day it was shaped, reads simply, "Wife of O. Healy."[5]

Oscar Healy didn't play grieving widower for long. When the twentieth century began, he met it with his own fresh start. He took a bride, the former Harriet Pygall, that summer of 1900 and pushed the brood west to Corvallis, where Roy spent the rest of his adolescence.[6]

The end came for the fifty-year-old Oscar in 1907,[7] and Harriet herself seemed to separate from the narrative (she died in Portland in 1916).[8] The brothers were adults by then. Bert had left Corvallis's Oregon Agricultural College (Oregon State University) two years earlier for a job in Cathlamet, Washington, hoping to return with enough money to finish school. He became a permanent resident instead, starting a family with his wife, Gertrude, and their children, Barbara, Leon and Roy, named as tribute to Bert's brother.

The Reverend Roy Healy served the First Christian Church from 1920 to 1922. The ornate towers, as seen here, were taken down in 1935, and the building itself fell in a March 1960 fire. *Courtesy of the Albany Regional Museum.*

Bert plied various trades for the rest of his life, from bookkeeper to county commissioner to stationary engineer. He was eulogized upon his 1934 passing at the age of fifty as "one of Cathlamet's best known citizens"; attorney J. Bruce Polwarth recalled, "As a friend he was steadfast and loyal; as a husband kindly, sympathetic and considerate; as a father he made of his children his best friends, and he entered in their hopes and happiness as his own."[9]

Roy stayed in Oregon, joining his aunt and uncle, Martha and Robert Healy, in Coburg.[10] There he met and courted Ada Belle Sidwell, the second oldest of Robert and Laura Sidwell's four daughters (a fifth, Bessie May, had died in 1903).[11] The Sidwells were a large family—eleven children[12]—and the women, perhaps through sheer number, couldn't help but enchant those Healy boys, as sparks soon flew between Ada's sister Edna and Roy's cousin Frank.[13] But the original union reached the altar first, tying the knot on the morning of June 20, 1911, in time to make that day's *Eugene Daily Guard*.[14] Ada was twenty-three and her husband twenty-four; Roy stands proud in a subsequent portrait, beside his smiling bride.

A 1914 directory finds the lovebirds at 1365 Onyx Street, a thirteen-minute stroll to Eugene Bible University (now Northwest Christian University), where Roy was enrolled as a student.[15] The college had expanded considerably beyond its 1895 origins as Eugene Divinity School, a rented building ample enough to house its five-strong student body. Nearly twenty years later, Healy and 120 of his peers paid $150 to $200 in annual tuition to wander the growing campus, whose crowning glory was its library's rare Bible collection.[16]

Traces lingered of humble roots. Its three original professors remained active: university president Eugene Sanderson, Hebrew instructor Ernest Wigmore and David Kellems, head of the Oratory Department, where the aspiring pastor sharpened his elocution. Healy graduated with a BSL degree in 1917 and later stood with the institution's most illustrious alumni in C.F. Sanders's *Making Disciples in Oregon* (1928).[17] A church newsletter described his values thusly: "Brother Healy preached the Word with force and in love. He believed the Book, the whole Book, and was faithful in his teachings and diligent in declaring it to others."[18]

Free from academia, and after a stint in Elmira, the reverend and his wife pressed north.[19] By then thirty-two, Roy nevertheless fulfilled his duty to God and country by registering for the draft during the Great War.[20] He listed his occupation as minister of the Christian church in Zillah, Washington, a tiny community of barely 650 souls.[21] Another arrived on July 31, 1918, when Ada gave birth to the couple's only child, Eleanor Gertrude Healy.[22]

Alas, the girl would never behold Zillah's pastoral beauty. Her nomadic family would soon make tracks again, spreading the gospel all the way to 155 Sycamore Street in Gridley, California,[23] proudly described even in contemporary literature as a homey, small-town escape.[24] They didn't stay long, however, returning to Oregon in the late summer of 1920.[25]

For now, their adventures were over. All traveled roads—winding, thorny and otherwise—had guided Roy Healy home. Time had thinned his coif and softened his features, widening his countenance to accommodate a calming smile.

"The ghosts of the past have not all betaken themselves to the otherwhere," Daniel Poling wrote in words that burned from every newsstand in town.

> *Deliver me from all such. The ghosts of tradition, of theology, of dogmatic faith, of rutted and grooved educational systems; the ghosts of ignorance; selfishness, hate, bigotry, self-centeredness—free from all such, I implore...*
>
> *Reward my brethren for all their kindness and love toward me in the past. I write this record on the tablets of my heart and spirit. Assist me, Lord, in this, my labor of love—*
>
> *And finally, I ask for myself, for my community, for my nation, a just and positive appreciation of the moral and spiritual values of life. A confession of faith in the invisible and intangible realities. Amen.*[26]

When 1922 had finally unfolded, in all of its shock and grief, many would quietly wonder if God had heard a word.

THE SHERIFF

I stand squarely on the right side of all moral questions and I shall sacrifice neither principle nor patriotism nor the interest of Linn County for politics.[27]

When the National Prohibition Act became law in 1919, Albany may have wondered what took so damn long. A hotbed of temperance for decades, the town had gone "dry" some thirteen years earlier.

Not that it was easy to take a drink, even when the juice ran wild. As the law then read, "Liquor may not be served to common drunkards, persons intoxicated, women, girls, minors or Indians."[28] None could enter a building where a single drop was poured. Sunday drinking was strictly forbidden. Everything appeared so perfect on the surface that the *Albany College Bulletin* confidently declared in 1911 that saloons were on the wane.

Eventually derided as a hectoring battalion, the temperance movement, in its powerful prime, was nothing to mock. Established in 1874, the Woman's Christian Temperance Union followed the lead of such earlier groups as the American Temperance Society and within a decade wielded influence far beyond its Hillsboro, Ohio base.[29]

The ladies took as their credo the wisdom of Greek philosopher Xenophon: "Moderation in all things healthful; total abstinence from all things harmful." As daughters, sisters, wives and mothers, many had experienced alcohol's ruin firsthand: physical abuse, financial ruin, humiliation, diminished faculties, illness, murder, death. But they didn't stop at the bottled menace;

under second president Frances Willard, they fought prostitution and for a woman's right to vote.[30]

By 1880, the WCTU had come to Oregon, tapping Elizabeth P. White of Portland as vice-president for the state. The first union formed there the following March; Albany received its own one month later. However, the region's first union-specific building went up in nearby Corvallis after that city's branch was evicted from its previous rented address. The two-story, thirty- by sixty-foot structure, with its free reading room and upstairs lodging, thrived despite heat from tavern owners. A local reportedly mused, "I believe it is conceded by all that W.C.T.U. of this city has been and is a great moral force, and that the reading room

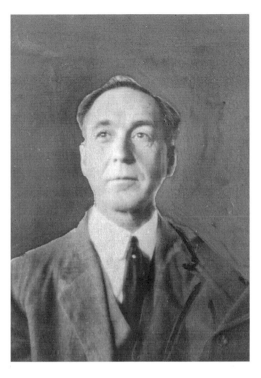

Sheriff Charles M. Kendall. *Courtesy of Judy and Terry Broughton.*

has done untold good. The saloons have decreased, owing, no doubt, partly at least to their influence." The group finally opened an Albany headquarters in 1887, coexisting peaceably with the Grand Army of the Republic, a club for honorably discharged Civil War veterans.[31]

As the nineteenth century ended, so did faith in temperance unions. They'd become too massive, too scattered in their scope. From this perception rose Oberlin, Ohio's Anti-Saloon League, which quickly became the fiercest and most cunning of teetotaler collectives.[32]

Crucial to its success was its American Issue Publishing Company, whose ceaseless press blanketed creation in magazines, pamphlets and newspapers. Manager Ernest Cherrington explained its strategy:

From this central publishing house there is to sweep a flood of anti-liquor literature, which with increasing volume and power will continue until by persistent application and by the constant wearing-away process, the stone of liquor domination which for so long has obstructed

the highway of progress shall have been forever gathered in powdered dust into the urn of history.[33]

Their publications often portrayed drinking as not just a social abomination or an affront to God but also as something much worse: hopelessly old-fashioned. The May 1912 cover of *American Patriot* magazine depicts a pair of gray-brushed, barrel-shaped rummies—one a brewer, the other a saloon keep—standing in a "Drunkard's Burying Ground," salivating over a stream of youth pouring into a nearby school. The barman laments, "Our best customers are dying every day." His partner suggests, "You must fill the ranks with the boys." Honestly, who wanted to age into fat, old predators or be obliterated by their own rotting guts?[34]

Abstinence was clear-eyed science. It was intelligence, optimism, evolution. Indulgence wallowed in fog-brained avarice. There was no place in an enlightened century for such swine. Sneered Albany College history professor F.L. Franklin in a 1915 *Oregon Teachers Monthly* column, "That alcohol is an elixir of life, an invaluable stimulant, a much-to-be-prized food, was for ages as credible and as generally known to be true as were those other sacred truths that the earth is flat and that the sun moves around it daily."[35]

Publicly, the tide appeared to be turning. But anyone game for a nip could find one, even in a dry community. Albany's more prominent souses bankrolled their own bootleggers and filled their cups in comfortable privacy. Others slipped out to blind pigs, lowdown kin to the more respectable speakeasy. "If you knew where the blind pig was," longtime resident Otho Franklin told the authors of *Ah, Yes…I Remember It Well* four generations after such venues were de rigueur, "you could buy beer."[36]

Liquor moved regularly through town, so authorities had to be as vigilant as traffickers were crafty. On the morning of Friday, January 31, 1919, a Southern Pacific Railroad detective, while inspecting the No. 55 northbound, came across a coffin emanating a peculiar odor. Curious, he cracked it open to find not mortal remains but enough bonded whiskey to preserve a mortuary—several dozen quarts, minus the telltale bottle that shattered. The detective continued with the shipment to Portland, where he planned to arrest the bereaved.[37]

That had nothing on the olfactory cloud forming over Fifth and Broadalbin earlier that month, when outgoing sheriff Daniel Harvey Bodine reflected on his six-year tenure while draining ninety-three pints of hooch—$644 worth (about $8,800 in 2015)—into the sewers outside the jailhouse. A somber audience witnessed this symphony of smashed glass and liquid temptation.

An *Albany Democrat* reporter captured the lawman's soliloquy:

> *During my time as sheriff, I have destroyed nearly 500 gallons of whiskey. At the present price, this could mean that I have put out of commission $28,000 worth of contraband liquor. Several local physicians and the hospital authorities have asked me at various times to supply their medical needs, but under the law as it now exists, I can not turn over this liquor without violating my oath of office. At one time I consulted the district attorney in regard to the matter, but was advised that legally I could not turn any portion of my stock over to the physicians. Despite the claim that liquor in moderate quantities is beneficial in the treatment of Spanish influenza, I have no alternative than to perform the duties of my office as the statutes describe.* [38]

Bodine was leaving—he'd soon return as the city recorder, a less dangerous pursuit—but the office was in capable hands. His successor, Charles M. Kendall, had been with the department for the better part of a decade, since becoming a deputy in October 1911. He'd outlined his qualifications in a newspaper campaign ad:

> *I was chief deputy in the office for over 18 months and I have served as a peace officer and outside deputy at different times over 10 years. My record is clean. My accounts are accurate. I never made a false arrest, never failed to get the man I went after and never lost a prisoner.* [39]

He did, however, lose his first bid for sheriff, but only by 7 votes in a 1916 squeaker. Although his Republican affiliation guaranteed a *Democrat* snub (the newspaper backed his opponent, W.J. Moore of Brownsville), he handily won the 1918 election, 2,811 votes to 1,496.[40] Even better news landed six days later, on November 11, when the Allies and Germany signed an armistice ending the Great War after four miserable years, clearing front pages of correspondence from the trenches, disheartening reports of hometown tolls and open threats against supposed "slackers" (what another generation would call "draft-dodgers").

Documenting Charles's early life has proven a labyrinth of blind turns and abrupt dead-ends. History keeps its secrets safe. According to his obituary, he was born in Chalfants, Ohio, on August 19, 1869[41] (or 1867, as his headstone reads). The town no longer exists, bleeding into Perry County anonymity (plug it into Google Earth and you'll land somewhere near Graber's Oak

Flooring & Pole Buildings on Gower Road in Glenford). His mother's name was Caroline Cochran. The 1880 census puts her in a Hopewell, Ohio residence with her brother, Samuel Cochran, and his family, plus her son, listed as Charles Cochran, age thirteen (which, admittedly, could be a simple mistake of identification).[42]

It is not known how or when he became a Kendall. Caroline appears to have married only once, very near the end of her life, to the widowed Joel Danison in the late 1800s. The Perry County, Ohio Probate Birth Index recorded twenty-one Kendalls and thirty-one Cochrans between 1867 and 1908. None was born to a mother named Caroline or on a date corresponding to Charles's birth, although a "Charley Cochran" was born

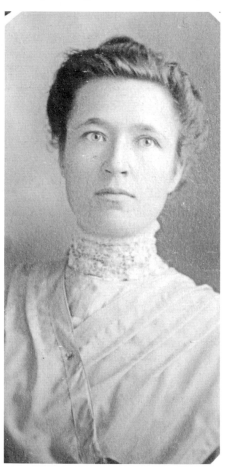

in 1891. It's possible that Charles came in 1866, the year before the county began keeping such records. From birth to death, no available evidence can identify a father, Kendall or otherwise. Considering the fact that Charles became a stage performer and interlocutor, "Kendall" could very well be a name he chose himself. Whatever the case, by 1901, Charles Cochran had become Charles M. Kendall.

At that point, he'd left Ohio for Iowa and then Kansas, where he met schoolteacher Edna Estella Scott—we'll call her Estella, which she seemed to prefer—of Jewell County's Athens Township. They were married in nearby Ionia on July 10, 1901.[43] Congratulations poured in; the Cochran cousins sent their best wishes, but someone couldn't help adding, "I have plenty of old shoes to throw at you, but the distance is to grate [*sic*]."[44] At twenty-eight, the blushing bride certainly wasn't following her mother's lead: Sarah Jane Scott had been with her

Estella Kendall. *Courtesy of Judy and Terry Broughton.*

husband, Walter, some twenty-three years her senior, more than half her life. Estella was the eldest of the four children she bore with Walter, in addition to the four he'd shared with his late first wife, Margaret.

The Kendalls next surfaced on the West Coast, in California. Their only child, Clark Scott Kendall, arrived at 8:45 a.m. on Tuesday, September 22, 1903, in the tiny Shasta County town of Millville. "He weighed 9 lbs. at birth and Dr. pronounced him to be an unusually large baby," Estella reported on December 5, as her now two-and-a-half-month-old bundle sat contentedly in her lap, his tiny little fist in his tiny little mouth. "He had short, thick black hair, very dark blue eyes, small ears, double chin and rather large nose."[45]

She kept diligent records of young Clark's development over the next year and two months, proudly chronicling his every move. "People make over him so much and think he is very attractive," she marveled on January 3, 1904, noting that a friend posed the question, "Would it make you very vain if I tell you your baby's the sweetest one around here?" One can almost feel her pride beaming through the paper.[46]

These documents also portray a young farm family becoming part of the community fabric. Estella played organ at the local church while Charles led the choir. Meanwhile, young Clark tanned beneath the Northern California sun, growing, laughing, discovering and playing with his father when Charles wasn't wrestling with asthma. Aspects of the child's character began taking shape, his temperament loving and sweet. He was fascinated by animals, especially horses, as he would always be. Among his first words, in addition to "Mama" and "how do," were "Whoa back."[47]

That fall, the Kendalls sold their Millville farm and pressed fifty miles south to Corning for the winter. Clark began walking and expanding both his horizons and his vocabulary. Every picture he saw he declared "pitty," and he'd silently mutter his own grace at the dining table. For Christmas, he received one dollar from his Grandma Scott, plus a table bell, a bank and a toy iron horse on wheels. Estella relayed all of this in her final entry, on February 5, 1905, ending with a most endearing example of her son's disposition. "He always goes to sleep with his hand under my chin," she wrote. "He always pets us that way. He will come to me and put his hand under my chin and say, 'Aw, mommie, mommie' so cute."[48]

The family entered Albany sometime later that year, perhaps after the U.S. federal census had completed its report in June, since the Kendalls are missing from the final tally. But they were definitely in the city, as evidenced by a letter Charles submitted from Albany to *Recreation* magazine, in response

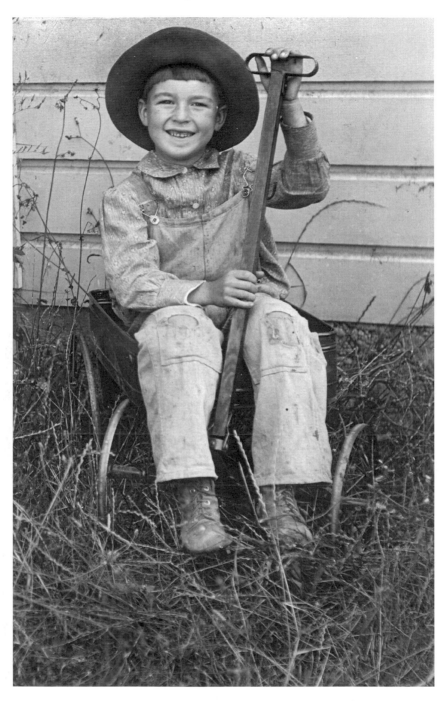

Clark Kendall playing at the Fifth Street house, 1909. Photo taken by Estella Kendall. *Courtesy of Judy and Terry Broughton.*

to a late 1905 article on "Ideal Belt Revolvers." He discusses his admiration for his .38-caliber Smith & Wesson, model 1902, despite its lack of heft. "It is from four to six ounces too light," he explained.

> *The barrel should be seven and one-half inches instead of six and one-half, and the grip is too light and too short. I have used a revolver for fifteen years, and I am thoroughly convinced that to do good shooting it is just as necessary to have a heavy revolver as it is to have a heavy rifle for target shooting.*[49]

The Kendalls had found a permanent home in this quiet Linn County town, minus an extended outing south in the summer of 1915 to seek relief for Charles's asthma. They moved three times in Albany before taking the sheriff's quarters over the jailhouse at Fifth and Broadalbin. First they lived at 940 East Fifth Street and then in a modest one-story at 972 East First Street; only the latter stands today. By 1911, they had secured more rural environs at the southeast corner of Sixth and Geary Streets in a house Charles built mostly himself.[50] During this time, he supported his family as a housepainter and wallpaper hanger,[51] although he was probably better known for his more formidable talents as an orator, speaker and impersonator. (His voice also bolstered a Methodist church quartet and led a men's Bible class.) In this guise, he was "Professor Kendall"—his sharp talent cultivated over many years.

His surviving effects include a weathered and frayed journal nevertheless lovingly maintained. In his rich, brilliant script (every page hand-numbered, although he'd stopped writing at page fifty-

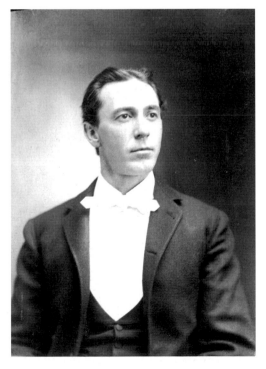

C.M. Kendall in his "Professor" garb, circa 1899 promotional shot. *Courtesy of Judy and Terry Broughton.*

three), he transcribed a handful of popular dramatic recitals, poems and stage scenes, from Le Roy Runcie's "Demetrius" and chunks of *Hamlet*—Somerset, Ohio's superintendent of public schools cited Kendall's grave scene, in which he essayed every character, as particularly fine: "[H]e made the action fit the sentiment and thereby showed by his change of voice, gestures and facial expression, that he was a real artist in portraying human life and character"[52]— to Willa Lloyd Jackson's stirring "Enemies Meet at Death's Door."

He leapt with ease from Shakespearean subtlety to jovial buffoonery, and his work was highly praised. "Am glad to give you a recommend," wrote Frank Cooper, Creswell, Oregon's principal of schools, in February 1907. "My only trouble is to make it strong enough."[53] L.R. Alderman, the state's public schools superintendent, had no such problems, stating in March 1911, "It is not flattering Mr. Kendall to say that he holds the interest of his audience in every number. Mr. Kendall has the happy faculty of knowing just when to intersperse pathos with humor and humor with pathos to drive his lesson home."[54]

Two months later, Kendall appeared at Columbia College's first May Festival in Milton, Oregon, joining a prestigious bill with concert violinist Wort S. Morse, Portland Rose Festival conductor Wilt Boyer and blind pianist Francis Richter, in addition to an eighty-five-member chorus and orchestra. He delivered multiple performances over the four-day period.[55]

His stage credentials were well established, but there's little to suggest any law enforcement experience prior to his arrival in Albany. If he became a deputy sheriff in 1911, then he began his career in his forties—today, he might be considered too old. But Kendall underwent no rigorous training. There were no academies or courses, and the Oregon State Police wouldn't exist until 1931.[56] He likely learned on the job, where his age and life experience may have been assets. But why would this man want to be a police officer?

"Charlie was a people person," said Judy Broughton, who, along with her husband, Terry, and daughter, Joy, knew Clark Kendall in his later years and today serves as caretaker/protector of the family's legacy. "He was an entertainer, and he got along well with everyone. He liked helping and serving. That's from what I can gather. Clark never did give a specific reason as to why his father chose to become sheriff."[57]

At the time, tenure wasn't a prerequisite for holding the office. You just needed votes. A decorated veteran could feasibly lose to a charismatic grocer. According to retired Linn County sheriff Art Martinak, this was fairly typical.[58] All that mattered was public exposure and essential connections, and

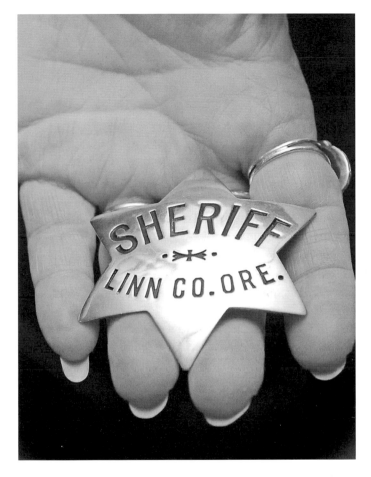

Judy Broughton holds Sheriff Kendall's badge, December 2014. *Jesse Skoubo*, Albany Democrat-Herald, *2014.*

Kendall had both in abundance. He was regarded as an honorable man, and he had important acquaintances, like county superintendent and *Albany Democrat* co-owner W.L. Jackson.

But Kendall had earned the little tin star. That much was evident in 1920, when he won a second term.[59] His constituents had found him as conscientious and honest as his campaign ads had promised. "I shall give prompt, efficient and accommodating service at all times,"[60] he'd sworn, and he'd made as good on this promise as circumstances permitted.

There were surely worse cops to cross. City marshal Johnny Catlin stood a hair around five-foot-five but packed a large revolver—a cannon he'd dubbed his "gat," once offering, rather colorfully, "I've got the old gat oiled

up and ready to use in case Albany is invaded by more thieves"[61]—and an unpredictable temperament. Once, at the train station, when a vagabond flashed a hint of lip, Catlin helpfully reset the offender's jaw with the butt-end of his weapon and watched five other transients pound him into civility.[62]

Kendall was the opposite: patient and kind. When a minor influenza epidemic plagued the county jail, he made sure it was contained and that its captive victims received treatment. He would be remembered by lawful and lawless alike as hospitable, trusting and compassionate—valuable attributes, all. But sometimes, sadly, they're liabilities, too.

January 1922

Is it wrong to shoot a man?[63]

As new year gaiety whooped through town, Carson Douglas "Pete" Beebe sat in limbo at the Linn County jail, his seemingly permanent quarters, as district attorney L. Guy Lewelling weighed his next move.

Just four days earlier, Beebe had been the focus of 1921's most sensational trial, a weird and twisted drama so captivating that the courthouse buzzed with constant life. Eventually, Judge Percy R. Kelly ordered loiterers to sit down or leave. Many lingered for hours, hovering to claim vacancies. No chair remained empty for long.[64]

The courtroom Beebe bore faint resemblance to the creature Sheriff Kendall had arrested in November. His long, brown locks had been cropped to presentable length, and he'd shorn the wild beard he'd sprouted behind bars.[65] He seemed bookish in his eyeglasses, wiry, tense and muscled.

But the prisoner was considered, in his time's cruel vernacular, "slow." He moved "funny" and acted "queer," and most everyone figured he had the sense of a six-year-old. (A more contemporary diagnosis may suggest a form of autism; Beebe seemed more socially than mentally challenged.) He suffered from weak vision, damaged long ago by cataracts. For most of his twenty-five years he'd been blind in one eye, damn near it in another,[66] until a pair of operations in Eugene in the late 1910s had restored his sight somewhat.[67] He wasn't sure what caused it originally—that bee attack when

Above: Excitement abounds outside the old Linn County jail, with the courthouse looming behind, in this undated photo taken after an attempted escape. *Courtesy of the Albany Regional Museum.*

Left: The Linn County Courthouse, built in 1865. A larger facility replaced it in 1940. *Courtesy of the Albany Regional Museum.*

he was three? His father, also named Carson, blamed a tumble from a wagon when his son was seven.[68]

Perhaps as a result of his longtime condition, Beebe could neither read nor write, nor did he pursue a formal education. Instead, he lived full time at his family's home in Crabtree, an unincorporated town about fifteen miles north of Lebanon. As the eldest of nine siblings (two girls, seven boys), he carried firstborn burdens. He matured into a headstrong man, so when he went to work for John Painter in nearby Lacomb, he probably enjoyed his first real taste of adult independence. He would never know such freedom again.

For eight December days, the curious came to the courthouse in waves, stalling Christmas preparations and braving snowfall to gander at the man so reviled in the press. "He…has the appearance of a degenerate," lashed the impartial (Albany) *Evening Herald*.[69] "Beebe is considered defective," spat the neutral *Lebanon Express*.[70] Although he wasn't one of the county's brightest blossoms, somehow he was the only one who survived what happened at the Painter farm. John Painter and his teenaged son, William, weren't as fortunate. And now a jury would determine if this so-called feeble-minded defective degenerate was crafty enough to commit first-degree murder.

No one had seen the Painters in nearly half a month when Beebe rode into Lebanon, hauling wood to sell, in late October. When anyone asked, he explained that his employers were away and he was in charge for a while. It sounded simple—if not quite plausible—but sometimes he'd alter a detail just enough to kindle further doubt.

Neighbors smelled a rat. Those who'd spoken to the Painters before their October 19 disappearance couldn't recall either mentioning an impending trip. It also seemed peculiar that John Painter, who had three other children (two daughters and a son, all married and gone) and, presumably, capable acquaintances, would leave his operation to a hired hand. Nor would he have allowed said hand to loan a bay horse team to his parents for a potato harvest, as Beebe had done on October 20.[71]

Questions began mounting, and the month was closing fast. Toward the end of its final week, Arthur Painter, John's other son, stopped in from Sweet Home and found no signs of life on the property. He reluctantly continued past but returned the next day to find everything still in place, untouched, unmoved. Alarmed, he and other neighbors called the county sheriff.[72]

When Charles Kendall arrived at noon on Saturday, October 29, the land was no longer uninhabited. Sandwich in hand, Beebe stirred from the cabin, yarn primed to spin. He told the lawman that the Painters had bickered ten days earlier over a borrowed block and tackle. Each then

made haste in separate directions, John to the east—presumably to his home state, Pennsylvania—and William to California, maybe to visit his sister, Rose Harding. In their absence, the elder Painter gave Beebe free reign, even allowing him to sell property and goods. He'd moved about $400 in wood so far.[73]

Whether the sheriff danced to this jazz is unknown, but when he noticed a blood-spotted .32-.20 rifle resting in a corner of the living room, he began posing more pointed questions. Beebe explained that they'd recently killed a sheep and the poor thing had bled everywhere.[74]

Dissatisfied, Kendall returned on Halloween for an expanded, alternate version of Beebe's scenario. In this instance, the Painters argued and retreated as before, but this time John leased the property to Beebe and paid for his labor with $800 in livestock. But that new wrinkle wasn't as curious as the bloodied shoes Kendall exhumed from beneath the stairwell or the pistol shell on the sitting room floor—both apparent sheep-hunt mementos.[75]

The following morning, Beebe opened the front door to a larger audience. Kendall was back, accompanied by Painter neighbor and deputy Frank Smith, Linn County district attorney L. Guy Lewelling and a coterie of concerned strangers. Smith, considered by many a human bloodhound, went to work and was soon pulling buckles and buttons from the cabin stove—hardly proof of murder but interesting all the same. And what to make of Beebe's slightly bloodstained spectacles? Spatter from a punctured boil, he said.[76]

Neighbor Earl Carlton finally got through: these men are here to arrest you, so why don't you just come clean? Beebe considered his predicament and unwrapped an impressive melodrama.[77]

The Painters, he admitted, were dead. He'd covered their bodies in brush and earth and shielded them from the elements with an enveloping patch of forest. But he'd only done as he'd been told.[78]

He kept the main elements from previous drafts. The block and tackle. The angry row. This time, however, when their conflagration continued into the cabin, it escalated into gunplay—sharp pops that Beebe, still working in the field, seemed neither startled nor concerned to have heard.

When the distant Lebanon Paper Mill whistle loosed its noontime shrill, he headed to the cabin for supper. Inside he found John Painter, grim, despondent. The older man announced that he'd murdered William, tucked his corpse in the barn and now, to repent, would turn his revolver on himself. As a last request, he asked Beebe to bury their bodies together. He'd already carved a chasm for two in a plot behind the house. In exchange, Beebe would receive everything.

Both men made good on their final promises.[79]

Beebe led his visitors to the sacred place, where father and son had reunited. He swept away debris, showed them where to dig. Shovels pierced soil, slowly uncovering the truth: two human forms, ravaged already by decomposition. John and William Painter—there could be no doubt. John Bem, who'd married John's daughter Gladys,[80] stood among those who confirmed it.[81] William was in his workclothes and his father clad in all but his shoes.[82] The latter had been dumped atop the former like a careless afterthought.

County coroner Everett Fisher gathered six men for a coroner's jury—D.C. Bellinger, W.T. Allphin, W.J. Mitchell, L.N. Harrison and A.J. Nicholls, all of Lebanon; and John Turnidge of Lacomb—and together they absorbed the survivor's account. Beebe struggled as he watched attendants secure the corpses and place them in a hearse. Fisher reported the verdict cautiously. Under "the cause of death in my opinion was," he wrote, "As found by jury—gunshot, inflicted by some unknown person."[83] But only on paper was the culprit anonymous. Kendall believed he had his man and hauled him back to Albany.

The Painters were driven to Lebanon, where Drs. R. Lee Wood and N.E. Irvine conducted an autopsy. They determined that William was shot once, the bullet penetrating his left hip bone and resulting in fatal internal hemorrhage. John's demise, however, wasn't as clean. For someone so determined to end his life, he managed to prolong his agony by shooting himself three times: once in his right leg, once in his right collarbone (fired from an angle that broke four ribs) and once in his left breast—all reportedly with a .32-.20 single-shot rifle that required a manual reload after every discharge. If John Painter's wounds were self-inflicted, he took an exceptionally painful way out. But the examiners retired that bunk after procuring from each body one .38-caliber bullet apiece.[84]

When Lewelling mentioned this discovery to Beebe, the latter recalled stashing such a weapon in the granary. Kendall returned to the scene and combed the structure clean. There it was: a .38 hidden above the door. Two shells were inside, one loaded and the other empty. He then drove out to the Beebe family home and retrieved the bay team young Carson had so proudly presented to his parents. The prisoner didn't take the news well, apparently lamenting over tear-drowned protestations that "a man could work forever to get something, and as soon as it was in his possession, someone could take it from him."[85]

Unbeknownst to Beebe, his father and younger brother George had been in town that day to speak with Lewelling but left without visiting the

incarcerated or even asking about his alleged crime. The papers made much of this apparent disinterest and of the fact that his parents, as a united front, had so far failed to surface (they'd meet with him that weekend, quelling gossipmongers.)[86] Alone, the prisoner cried and moaned himself to sleep.[87]

On Wednesday, November 3, Beebe appeared for his preliminary hearing inside the library at Albany's First National Bank. At his side sat former district attorney Gale S. Hill of the local Hill & Marks firm, as appointed by Justice of the Peace Victor Olliver. Prosecutor Lewelling recited the charges, accusing the accused of "purposely, premeditatedly, and deliberately murdering John and William Painter." Wounded, Beebe barked, "I didn't do it!"[88] and wept into his hands. Hill shushed him; now wasn't the time for outbursts. Beebe remained stoic through the rest of the brief proceedings—only Kendall testified—taking cues from his appointed champion. Soon the ordeal ended, and it was decided that Beebe would face the grand jury during the circuit court's December term. Back he went to his cell and another fitful rest.

The grieving Painters, meanwhile, buried father and son—properly this time—at the Foster Cemetery in Lebanon.[89]

Theories powered the rumor mill. Amateur shamuses deduced that Beebe must have had a silent partner, some puppetmaster pulling the strings. Others pondered the depth of the family's involvement; had they sacrificed one of their own? Lewelling deflated such talk as nonsense. "The murder was deliberately planned and carried out in detail," he told the *Lebanon Express*. "And it was planned for at least three months before it was committed. Beebe is the man who planned it and who is responsible for it, and no other person is implicated."[90]

The defendant's father began spending more time at the Hill & Marks offices near the courthouse, soliciting legal advice and asking the firm's lead attorney to take the case. While Lewelling planned to present the accused as calculating and shrewd, Hill's strategy painted Beebe as a wild idiot susceptible to manipulation. So in order to win, Beebe would have to produce witnesses willing to testify that he was stupid and crazy when he was, in fact, neither.

Reporter Charles Alexander, for his part, found the prisoner childlike, regarding his surroundings through still-new vision. He sat with Beebe for a feature, peppering the young man with such profundities as "Were your parents strange? Were you surprised to find them in their real form, their forms of flesh?"

"I didn't know them," Beebe replied. "I never knew they were like—that."

Later, he spoke of post-trial life, when he could hopefully abandon this cell and the metropolitan trappings around him: "When I get out of this, I'll

go back to the country. I'll never live anywhere else. There's nothing in the city for any man."[91]

At thirty-eight pages in length, sans transcripts, the file for Case No. 11747, *The State of Oregon v. Carson D. Beebe*,[92] is a testament to the trial's significance. It begins with the grand jury's December 1 indictment of the defendant for the first-degree murder of John Painter; William was a separate matter to be tried at a later date.

The following morning, Beebe stood before Judge Percy Kelly for his arraignment. When Kelly asked if he had representation, Beebe shook his head and answered, "No."

"Have you means of obtaining a counsel?" Kelly asked.

According to the on-scene *Lebanon Express* reporter, Beebe seemed momentarily confused by the question but recovered to reply that, no, he lacked such means. To no one's shock, the court appointed Gale S. Hill. Marion County district attorney John H. Carson would support Lewelling for the prosecution.[93] All were present on December 3 when Beebe pleaded not guilty, and the trial was set for December 19.

Both attorneys went to work, filing forests of subpoenas. Lewelling fired first, requesting fifteen witnesses in a single document, explaining in the December 12 notice that "more than five witnesses are necessary." Three would testify that Beebe carried a pistol; two saw him driving the bay team to his parents' home; one claimed Painter would never have parted with said team; and still another had traded the alleged murder weapon to Beebe. Not to be outdone, Hill responded four days later with an order for nine witnesses, including his client's parents and brother, George. Three others would describe his mental state the day the Painters died.[94]

Thus engaged, Lewelling filed nine additional subpoenas of his own the following morning, all for Lebanon residents who'd purchased wood from the defendant. By the end of the day, five more witnesses had been called for the defense. Then, on December 19, the day the trial was supposed to begin, Hill authored an affidavit—Beebe signed off with his mark, a standing cross—seeking one final man, Arthur Bass. Despite its legalese, it reads as an appeal to a lifelong friend:

> [I]*f called as a witness in my behalf,* [Arthur] *will testify that he has known me since I was about one year of age and that he has resided with my family during the time I was a small child and has known me continuously from the time of his first acquaintance until this date; that said Arthur Bass has resided in the same vicinity in which I have lived*

for practically all my life and during that time has upon many occasions seen me and talked with me and will testify that, in his opinion, I was insane during the month of October, 1921; said Arthur Bass has observed me under different circumstances and conditions than any other witness heretofore subpoenaed by me in this cause.[95]

Since so few in the county were oblivious to the Painter case, and many had passionate opinions, jury selection proved a three-day ordeal. But shortly after 11:00 a.m. on Wednesday, December 21, William J. Wilson, W.C. Burkhart, D.J. Hildreth, W.C. Cooley, Lee Miller, Albert H. Piper, E.L. Davis, W.C. Burns, John Steen, C.H. Davidson, Joel S. Faulkner and S.M. Bassett—"twelve good and lawful men of Linn County"—were entered into the official record.[96] Their first order of business was a sixty-mile round trip with the defendant to the murder scene; the trial proper would begin at nine o'clock the next morning.[97]

Lewelling opened Thursday by reviewing the crime, describing all eleven exhibits, untangling Beebe's conflicting accounts, relating graphic details of the Painters' corpses (at which point the defendant burst into tears) and, finally, assigning a simple motive: Beebe wanted what the Painters had.

Hill tore into his opponent, calling his evidence weak in its zeal to convict an addled cripple. "The state has based its case only upon guess work," he harrumphed, "and the defendant is merely the victim of the state's poor guess."[98]

By noon, only two witnesses had taken the stand: surveyor Charles Leonard, who'd constructed a model of the Painter spread, and Sheriff Kendall, who recounted his multiple visits. That afternoon, John Bem, son- and brother-in-law to the deceased, discussed his experience at the shallow grave. He was followed by official testimony from Fisher and Dr. R.L. Wood regarding the bodies' condition.[99]

The trial continued for three more days, breaking only for Christmas and Monday, December 26. The prosecution challenged the defense's contention that Carson "Pete" Beebe was an imbecile; John Carson coaxed Beebe's own father into admitting that his son owned livestock and carried a firearm—not bad for a fool supposedly incapable of self-support or discerning right from wrong. Testifying under considerable fatigue, family matriarch Lizzie Beebe sighed that her child was beyond education or discipline. Mr. and Mrs. J.D. Wassom recalled the defendant's lifelong odd behavior and said that it intensified after the operation to restore his sight. They also claimed that the young man, who spent six months at

their Coburg home, was an eager worker but largely useless. He lacked the capacity to learn.[100]

Four witnesses relayed incidents of Beebe's insanity (one, Otto Paetsch, was also called to describe a 1920 disagreement between the Painters), citing his crazy laugh, strange gait and "peculiar manner of holding his head."[101] Linchpin witness Arthur Bass regaled the courtroom with his diagnoses, informed largely by "Dr. Pierce's doctor book"[102]—or, more precisely, Ray Vaughn Pierce's once-popular and long-since-discredited *The People's Common Sense Medical Adviser in Plain English*, first published nearly a half century earlier and on its ninety-first edition by 1918, four years after the U.S. representative and tonic-shiller's death.

But it was Carson Douglas "Pete" Beebe himself who sparked the most interest when he took the hot seat on Saturday, December 24. Those anticipating a sideshow were sorely disappointed, for the defendant, save the occasional throat lump or memory lapse, kept steady. Two hours passed as he recited his story once more, adding details missing from his original statement. He revived again the quarrel and the gunshots, but this time he stopped at the barn en route to the cabin. There he encountered the dying William Painter weeping between a pair of mangers. "What's the matter, Bill?" Beebe asked. The boy did not respond.

Back at the cabin, John Painter confessed to his crime and announced his suicide. He asked his charge, now his only witness, to deliver $4 to Earl Carlton's wife in exchange for four loaves of bread and to give whatever was left to a harvest hand. Then followed a $450 payment, plus instructions regarding property maintenance, taxes and, finally, body disposal.

Beebe left the cabin to feed the animals; Painter trailed behind him, gripping his .32-.20. "I turned my head away and started to cry," Beebe testified. "I heard a shot. Then I heard another. I believe there was perhaps a third. After that I went to Painter's side. He was not yet dead. The revolver I had traded to him for his watch lay nearby. 'Take that thing and throw it away,' he told me. I was unnerved and was still crying. I took the gun, but I didn't throw it away. I put it in the granary instead. I don't know which gun he used, for I couldn't stand to see him kill himself."

Upon cross-examination, Lewelling went straight to the point: did the defendant murder the Painters?

"I did not," Beebe said.

"Would you shoot anyone?"

"No. I wouldn't have the heart."

"Is it wrong to shoot a man?"

"Yes."

"Why didn't you stop John Painter from shooting himself?"

"How could I stop him?"

"Was it wrong for Painter to kill himself?"

"Well," Beebe reasoned, "I suppose he had a right to do it if he wanted to."[103]

The attorneys delivered their closing arguments at 10:00 a.m. on Tuesday, December 27. John Carson spoke for one hour for the prosecution, reminding the jury of Beebe's three diverging narratives—four, if you counted the one he'd dumped in court—every one altered to accommodate new evidence. The state offered its own story: Carson Beebe killed William Painter in the barn, then entered the cabin and shot John Painter in the leg. When the older man buckled, Beebe drove two more bullets into him. It was that simple. The defense had developed its insanity ploy to divert attention from a rather obvious crime.

Effective as it was, John Carson's monologue fell to Gale Hill's talkathon. Try as it might, the attorney claimed, the prosecution could not connect his client, this "poor, unfortunate, half-witted boy,"[104] to anything. Officials had subjected Beebe to harassment, capitalizing on his deficiencies and confusing him into stories he couldn't keep straight. He was easy prey to anyone: John Painter, Earl Carlton, various officers of the law. And how was it that deputy Frank Smith, who resided in the vicinity and knew the deceased, found evidence at the crime scene where others had not?

Beebe couldn't read, so he was ignorant of novels and their machinations; therefore, he couldn't concoct such pulpy plots on his own. Also, John Painter could very easily have shot himself from the angles at which the bullets pierced his flesh, as Hill then demonstrated using the weapon in question. "If you condemn this man to die on testimony you have heard," he thundered at the jury, "your act will haunt you to your dying days."[105]

Lewelling wrapped up by hotly contesting some of Hill's more inflammatory accusations. No one had tampered with or planted evidence. Beebe was receiving fair treatment in prison. As for the defendant's so-called insanity, yes, incidents were cited that both supported and opposed that claim, but Dr. L.F. Griffith, the chief medical advisor at the State Hospital in Salem—the very institution to which Beebe might be committed!—concluded that the defendant was sane. "I ask," Lewelling implored, "in the name of organized society, that we be not returned to the plane of mob law; no matter how painful it may be to you—I ask you to do your duty."[106]

Judge Kelly spent nearly an hour dissecting that duty for the jury. Reason and logic must trump opinion. Did the presented evidence support

a motive? A number of verdicts were possible: first-degree murder with recommendations; second-degree murder; manslaughter; not guilty on the ground of insanity; and, finally, not guilty. Around 5:15 p.m., the twelve men exited the courtroom, exhausted.[107]

Morning brought nothing. The jury deliberated privately for most of the day, finally surfacing at 3:30 p.m. to meet with Kelly. Then they vanished again and returned within a few minutes. The verdict was read to the court: "We the jury…find the above named defendant, Carson D. Beebe, not guilty on the ground of insanity."[108]

Various reactions hummed through the room. The Beebes looked understandably distressed. The defendant's face betrayed nothing, though he tipped to one side to quietly ask what would become of the second indictment, the one for William Painter.[109] The question would hang like a phantom for a while. As of January 1, Carson Douglas Beebe was still in custody, a man without a future.

Therefore, he missed Roy Healy's inspiring speech that Wednesday, January 4, at Albany College's chapel service. Among the attendees was nineteen-year-old Clark Kendall, halfway through his freshman year. Observing the theme "Following the Rainbow," the Christian church minister outlined "many fundamental facts that should be heeded by young men or women on the voyage of life."[110] For his own Sunday congregation, Healy contemplated "The Second Coming of Jesus Christ."[111]

Later that month, he penned a eulogy for community leader J.M. Hawkins, addressing three hundred mourners at the Masonic temple.[112] He was also present for the joy of beginnings, collaborating on a surprise wedding at his church between Wilbur Thomas and Jennie Louise Christy (caught unaware, the bride's father recovered in good spirits), then joining Sweet Home farmer William L. Burnett and Lebanon schoolteacher Loleta M. Barr[113] in a union that lasted almost sixty years.

Meanwhile, the revived Ku Klux Klan began canvassing the town with recruitment materials bearing the slogan "*Non Silba Sed Anthar,*" or "Not for self but for others." A circular promoted a far less inclusive message: "America for Americans." Those who sympathized with such sentiments were encouraged to visit the organization's makeshift headquarters in Room 630 at the Hotel Albany on Friday, January 27. An insidious seed flowered in similar meetings around the state.[114]

Sheriff Charles Kendall, a more pure example of "not for self but for others," wasn't around that day to monitor the Klan's activities. Instead, he escorted John Thomas Grant to Portland to faces charges of nonsupport.

Kendall had his own business in the city, joining his brethren at the state sheriff convention. It proved an excellent excuse for a winter family getaway. Estella visited relatives while Clark, a wild young man in a thriving metropolis, ogled shiny curves at the twelfth-annual Portland Auto Show. After months of lies, murder, courtrooms and headlines, this was the way to start a new year.[115]

FEBRUARY

There was a time when screen comedian Roscoe "Fatty" Arbuckle was so beloved that a separate man of identical girth could zip through the mid–Willamette Valley and land on the local paper's front page, an oblivious victim of mistaken identity.[116]

But by the end of 1921, people kept their distance from any association, real or happenstance, with the actor. That September, Arbuckle had been accused of raping and accidentally killing aspiring starlet Virginia Rappe at the St. Francis Hotel in San Francisco. His actual innocence or guilt would prove immaterial, as he suffered three humiliating trials,[117] all costly in every regard.

By February 2, 1922, the *Albany Democrat* no longer reported whimsical Arbuckle anecdotes. Instead, it devoted acreage to his crucifixion, along with a local item involving Eddie La Montagne, who managed a recurring "General Store" feature at the downtown Globe Theater and understood publicity. La Montagne announced that he'd sent the sinking icon a lucrative offer to join a national touring novelty show that La Montagne, of course, would orchestrate. The impresario was confident of Arbuckle's innocence, although he was careful to assure readers that he'd rescind his proposition should a jury decide otherwise.

"If he is (acquitted)," La Montagne declared, "he will be a great drawing card, so good a drawing card, in fact, that I will send him a contract for $2,500 a week as soon as he is freed. He would play more important towns and frequently in Portland."[118]

Arbuckle's second trial ended the following day with a second deadlock. Back the actor went to the defendant's table, where he remained until April 12, when a third jury cleared him and appended the merciful postscript: "Acquittal is not enough for Roscoe Arbuckle. We feel that a great injustice has been done to him…We wish him success and hope that the American people will take the judgment of fourteen men and women that Roscoe Arbuckle is entirely innocent and free from blame."[119]

If La Montagne ever did make an offer, Arbuckle either declined or ignored it. He went to work restoring his reputation. Alas, his career would never truly recover, thanks to Hollywood's aggressive new moralist, Will Hays, who banned the actor from making films in America and insisted exhibitors pull his titles. Arbuckle died in 1933, in the midst of a minor comeback.[120]

News of La Montagne's proposition came the same day as news of another movie-land horror: the death of director William Desmond Taylor, whose body had been found in his bungalow that very morning.[121] The case was ripe with intrigue: controlling stage mothers, raging jealousies, depravity and coverups. Actress/ingénue Mary Miles Minter was implicated, as was, interestingly, Arbuckle's frequent onscreen partner Mabel Normand. The murder remains unsolved nearly ninety-five years later, despite the fevered sleuthing of the cult that keeps it fresh.

Tinseltown was losing its allure, although film as entertainment and means of edification still proved useful. For example, on Sunday, February 19, Roy Healy presented to his congregation a three-reeler called *Alice in Hungerland*, which depicted troubled conditions in the Near East and what relief brought to its periled people. Even in silence, images proved more effective than sermons.[122]

Southern California and its biggest industry were suffering no such plight; its godless excesses and salacious scandals were all self-wrought. A snarky *Democrat* editorial spoke to this later that month. "The moving picture business would do well to clean house of this trash," snarled its author, "and, as a beginning, producers might place a higher premium on brains."[123]

Russian émigré Mike Kulugan wasn't using his noodle when he appeared before Justice Olliver on Tuesday, February 7, and declared, through interpreter Ed Rogoway, that he wasn't producing illegal intoxicants at his residence near Peoria but a mash for the hay he fed to his horses. The mix packed quite a wallop—0.08 percent alcohol by weight and 10.50 percent by volume—too much for livestock to consume. Olliver fined him $200; Kulugan opted for one hundred days in jail instead. He was later joined

in the pokey by B.B. Nichols, nabbed by Sheriff Kendall at the St. Charles Hotel on a booze-possession charge and sentenced to fifty days.[124]

Kendall cracked down in other areas as well, announcing that licensed automobile drivers without identifying plates would be arrested[125] (Ada Healy and daughter Eleanor returned from a family visit in Eugene that day, February 10)[126] and that, despite its lack of popularity, the state dog-tax law would be enforced to the tune of a ten-dollar fine.[127] Also, that month he walked into a billiard hall, where he encountered a group of minors at a table and exited with the business's proprietor, Henri Richi, in cuffs.[128] Richi paid a twenty-five-dollar fine for admitting underage patrons[129] and, curiously, left town.[130]

The year's shortest month didn't pass without tragedy. On Tuesday, February 22, First National Bank cashier Ralph McKechnie limped home early with the harsh beginnings of a cold that would blossom into pneumonia.[131] Two days later, Methodist Church pastor Willett Justice Bowerman, sixty-seven, succumbed most freakishly at his Albany residence to anthrax contracted from a shaving brush. "The attending physicians telegraphed to Seattle for a serum said to be the only remedy that will effect a cure," the *Democrat* reported, "but the serum failed to come."[132] No such hope would exist for McKechnie.

MARCH

It is the little things—the nothings or details—that go to make up great men and women.[133]

William Morris and Frank Gunning Wyatt's *Mrs. Temple's Telegram* premiered at New York's Madison Square Theatre in February 1905 and was, by most accounts, a smash. When published, its Samuel French companion offered the helpful note: "Much of the success of the play on its original production was due to the fact that it was played in a natural, quiet and serious manner."[134]

A tall order, considering its harebrained plot: the flirtatious yet very married Jack Temple resists a temptress but, certain his wife won't believe him, concocts an alibi involving a nonexistent friend, John Brown. Skeptical, Mrs. Temple fires a query to this "partner." Of course, it reaches a flesh-and-bone John Brown (or someone pretending to be), who descends on the Temple home for the usual farcical hijinks.

The play carried enough momentum to warrant a 1920 film adaptation, directed by James Cruze.[135] Two years later, the good Reverend Poling, the very man whose New Year sermon had sounded 'cross the *Democrat*, cast his own stage production for Albany College and booked two evenings, February 28 and March 1, in Albany and in the small community of Riverside.[136]

A decade removed from the Great White Way, *Telegram* found a receptive audience in this modest opposite-coast enclave, save one minor complaint. Despite its relative vintage, the play managed to shock those who preferred

their escapes, as essayed by unlined youth, sans particular indulgences. The subject matter wasn't the problem—who didn't love a roaring tale of adultery?—but the characters' behavior.[137]

It began within minutes of the opening curtain, when the actor playing Wigson, the Temples' droll servant, made his first entrance. He crossed the stage alone, bringing witnesses up to speed. "Master is up to his old tricks," he confided. "Missus won't be down for some time, and I always enjoy my cigarette after my coffee."[138] With that, he struck a match and made contact with tobacco, much to the gallery's silent alarm.

Telegram featured six instances of smoking in all, most of them integral to their scenes, either in reference ("You may smoke if you like," Mrs. Temple tells the faux Mr. Brown) or action (Mr. Temple lights up with a torn bit of newspaper, commenting on his ingenuity).[139]

Upon hearing of *Telegram*'s offense, Poling stepped in. "The actors are required to take only a dozen or so puffs of a cigarette without which the scene would fall flat," he explained to the *Democrat*. "It is I who should be blamed, and not the college, inasmuch as I was director and had entire charge of the arrangement of the play. It is not fair to hold the college authorities responsible for what they knew nothing of until the play was produced."[140]

This minor scandal was soon overshadowed by the unexpected demise of forty-six-year-old Ralph McKechnie, the gentleman who, racked with fever, hobbled home from his post at First National Bank. What began as a vicious cold mutated into a pneumonia that weakened his heart. Bedridden, he passed at noon on Saturday, March 4, at his home on Fourth Street. The longtime cashier left behind a wife and four young children, including five-month-old twins.[141] As the Christian church's chairman, McKechnie had celebrated Reverend Healy's 1921 achievements; in return, Healy would preside over his friend's farewell. All city banks closed in tribute at 1:00 p.m. the following Tuesday,[142] and many made way to the Masonic Cemetery to pay their respects.[143]

Meanwhile, history was quietly transpiring at the Linn County Courthouse with the selection of four women from an eleven-woman jury panel pool. The day before Mr. McKechnie's burial, Fannie Grubb became the first woman chosen for a county grand jury, a distinction she shared with Mary McLane and Theodosia Hardin. Together, they'd hear an otherwise ordinary case involving a lease dispute between A.M. Templeton and F.M. Franklin.[144] Hardin, alas, was excused for a family illness and missed another landmark moment,[145] when McLane was named Albany's first jury forewoman. It was she who announced the verdict—after an hour and a half's deliberation,

they found for Templeton—in the presence of the county's first female bailiff, Leila Mitchell (overseen, of course, by a male counterpart). The city flogged the publicity for every wheeze of steam.[146]

As lawyer Amor Tussing led A.M. Templeton to civil court glory, his colleague, district attorney L. Guy Lewelling, drafted a document that at last decided the fate of a man still languishing in jail:

> [I]t appearing to the court that on the 28th day of December, 1921, such proceedings were duly had herein that after trial by [Carson D. Beebe] was acquitted upon the ground of insanity of the crime charged in the indictment herein, the same being Murder in the First Degree, alleged to have been committed by killing one John Painter; that since said acquittal herein on said ground of insanity, defendant has been held without bail by the sheriff of Linn County, upon a bench warrant issued in case No. 11.746 wherein said defendant was charged with the crime of Murder in the First Degree alleged to have been committed by killing one William Painter; and that on this third day of March, 1922, said case 11.746 has been dismissed upon notion of the District Attorney for the purpose of rendering effective an order committing said defendant herein to said Oregon State Hospital.[147]

Beebe, for his part, wasn't finished telling stories. Two days before his transfer to the Oregon State Hospital, he spewed another whopper, this time for institution physician Dr. John C. Evans. He now admitted to killing John and William Painter, but only in self-defense. Previous versions had cast John as a morose, regretful killer. Now he was a vicious drunk, returned from Lacomb the day before the murder with clover seed and moonshine. All three drank of the latter deep into nightfall and resumed in the morning. Loose tongues between the older men resulted in wounded feelings, followed by an all-out mêlée. A knock to the bean sent Beebe running, but before he could get out the door, John Painter grabbed his shotgun from the kitchen, eager to deliver his hired hand to the angels. Beebe produced a revolver and ended that threat in three quick bursts. Frightened, William Painter took flight. Beebe couldn't have him blabbing to neighbors, so he ran the boy down and ended that threat, too. Later he wrapped John Painter's body in a blanket and stored it in the barn. His son joined him shortly. After that, Beebe delivered the bay team to his parents and returned to the scene of the crime, where he buried his victims the following morning.[148]

Despite Beebe's reported relief following his confession's new coat, neither Lewelling nor Beebe's attorney, Gale S. Hill, bit.

"There are certain physical facts which make this confession absolutely untrue," Lewelling said,

> and it is my opinion that this jug of moonshine and the drunken brawl which followed…never existed. Neither was there any injury on the body of Beebe. The evidence further shows conclusively that the bodies were buried while they were yet warm, the quilt in which the body was wrapped shows that it was taken from around the body while it was yet wet…In short, I do not take much stock in this alleged confession, except that I do believe he killed both the Painters without any help, and for the purpose of obtaining the big team and other personal property.[149]

Hill stuck to his winning defense. "All I know of Pete Beebe's alleged confession is as related in the papers," he said in a statement.

> If he has made this confession as reported, it confirms the opinion I have always maintained as to his mental irresponsibility…As at present advised I think Pete's supposed confession is merely the result of suggestion to which his child's mind succumbed. Apparently he is now in a mental condition to readily confess along the line of any suggestion which may be made to him. With proper suggestion I believe he would now clear up the Hollywood mystery and join the ranks of the several persons who have confessed to the killing of William Desmond Taylor.[150]

Although hospital physicians concurred with Hill's assessment of his client's mentality, they disagreed with the court's diagnosis and decision. "He is not insane," an unidentified expert remarked, "and should not have been sent to this hospital."[151] But there Beebe remained until his death of intestinal tuberculosis at age thirty, on May 29, 1927, five years after he was committed.[152] (He's still on the premises, in fact. As of 2015, his ashes have yet to be claimed.)[153]

Beebe was replaced in the Linn County jail by Sweet Home's C.W. Rowley, sentenced to one hundred days on a deer-meat charge. Unfortunately, he brought influenza, forcing Sheriff Kendall to call a doctor and do his best to quarantine a potential epidemic.[154] The threat was minor, luckily, infecting only Sweet Home's Ralph Overholser (larceny), who recovered after a brief confinement to bed.[155]

Louise Lovely starred opposite Lew Cody in *The Butterfly Man*, released in 1920. Taken from *Motion Picture News*, March 27, 1920.

A fever of a different sort spread through the city with the March 16 arrival of silent film actress Louise Lovely (no such fanfare met the Healys' return from Eugene, where Roy had held court at the Pacific Coast Congress of Christian Churches),[156] touring the country with then-husband Wilton

Welch and an ambitious multimedia act: a vaudeville presentation called *Their Wedding Night*; an audience-participation motion-picture production/talent search, *A Day at the Studio*, in which Welch would film and Lovely would direct star-struck locals (audiences would return the following week for screenings of the results); and her most recent dramatic five-reeler, 1921's *Life's Great Question*.[157]

At the ripe age of twenty-seven, the former Nellie Louise Alberti[158] was on her way down, as far as Hollywood was concerned. She would complete one last picture, *Jeweled Nights*, in 1925, a year after returning to her native Australia (she died in the city of Hobart in 1980).[159] Albany, however, lavished her in worship. The *Democrat* reported her itinerary from the moment the flaxen-locked beauty, once compared to Mary Pickford,[160] set foot on town soil before being whisked to the Hotel Albany in a Buick Six furnished by the Murphy Auto Company. Her aura sent a scribe into smitten fits, fawning over her appearance and fetching accent, which he'd mistaken as English. "Miss Lovely has a charming personality," he gushed. "She has large, blue eyes and golden hair. A small hat of blue material matches her eyes. The rest of her attire, which, of course, is the mode, is more than a mere man reporter can satisfactorily describe for women readers."[161]

Shortly after settling in, Ms. Lovely went downstairs to greet Globe Theater proprietor C.G. Rawlings, who escorted her to the courthouse for photographs and then to the theater, where more cameras awaited. At 3:00 p.m., she captivated an Albany High School assembly with stories of movie stars, including those so recently in the news. Despite her own issues with the industry, she defended her adopted town and shared with students the true measure of prosperity. "It is the little things—the nothings, or details—that go to make up great men and women," she said. "The capacity to learn the bigger things and at the same time, to grasp all of the details that to us at the time seem trivial, is the element that makes for success in any line."[162]

Merchants found novel ways to associate with the actress. "LOVELY!" bellowed an advertisement for the Rexall-affiliated Fred Dawson's. "That's what you'll say when you use Cara Nome, Bouquet Ramee and Jonteel. The highest grade toilet preparations. They are recommended by the leading stage and screen stars everywhere." Lovely's delicate neck was caped in pearls, compliments of F.M. French & Sons Jewelers and Opticians. Striking arrangements from Albany Floral Co. lined the Globe's stage. While in town, she corresponded on Whiting's Organdie, available at Rawling's Print & Stationery, under illumination provided by a rose lamp courtesy of The Electric Store. "The Furniture Question Is Not 'Life's Big Question,'"

announced Fortmiller Furniture Co., but there was no question whose couches and chairs cushioned Ms. Lovely's form.[163]

Albany made such a supreme fuss that when English comedian Harry Tate brought his London Follies to the Globe later that month, he couldn't have hoped for even half that reception. No one cared a whit for his toiletries.

APRIL

I have found that every time I have disregarded my father's advice,
I got into a scrape of some kind.[164]

Russell Hecker hit town under a late night's cloak. The twenty-four-year-old carved familiar roads, ones he'd known as a boy, before the madness of events that brought him home. He passed his parents' house on Ninth Street but didn't stop; they were likely long asleep, and anyway, the fewer people aware of him the better.[165]

He seemed intent as his car tied knots through the city. Finally, he turned down Fifteenth Street (now Queen Avenue) and fell into nowhere. Perfect. At last he rolled to an ancient wooden horse bridge that crossed the Calapooia River and connected the end of town to a lonely stretch toward Corvallis. It was an isolated spot; no development would come for ages. He was alone, darkness his accomplice.[166]

Hecker slips through time just as furtively. Born on April 1, 1898, in California, he spent a good part of his young life in Benton County's Soap Creek region, settled by hardy folks like his grandparents. Joseph Hecker had emigrated from his native Germany to the United States as a teenager in the 1850s[167] and had, within a decade, forged west from Philadelphia, married and settled into what was then Benton's "Subdivision 5." His wife, Minerva, bore him ten children, including Russell's father, Bernard, who answered to the friendlier "Barney,"[168] even if his maneuverings were sometimes dubious. Barney was a land

man, too—real estate—and he handled Joseph's ranch, as well as other properties throughout Oregon.

Although newspapers would report that Russell was "educated in the Albany public schools,"[169] he doesn't seem to have ventured far. He appears in not a single Albany or Corvallis high school annual between 1910 and 1920; younger brother Ralph beams anonymously from Albany Union High School group shots in 1916 and '17 but vanishes thereafter. (Ralph would have graduated with the class of 1920, preceding Clark Kendall by a year.) At that point, Russell may have been living in Humboldt County, California; a 1918 draft card lists his occupation as waiter at the Albany Grill in Eureka. He may have also spent time in Montana, working as a projectionist for Paul Noble, later the manager of Portland's Liberty Theater. By 1920, Hecker was in that big city, too, joining Noble at the Liberty and earning ink for assorted devilry.[170]

But on April 16, 1922, Hecker was in Albany, weary from a long, fraught night. Around 2:00 a.m. on April 17, he was spotted filling up at a local service station. Then he checked into the Hotel Albany, greeting night clerk Clifford Westbrook behind the desk and signing the registry. He booked a room, where, over the next half hour to two hours, he freshened up with a bath and penned letters. Afterward, he put pen to envelope, replacing its existing sentiment, "Merry Christmas," with "by a friend for a short time." He then purchased cigarettes from Westbrook and five two-cent stamps, which he used to close the envelope.[171]

He made one last stop before leaving town, stirring Ira Coleman and his wife from a still-fresh slumber. The visit was brief but memorable. Hecker repaid a $65 loan and then handed Coleman the envelope—now cash-fat, too much for one man to safely possess. "This contains $634 [about $8,900 in 2015], which belongs to somebody else," he explained, "and I want you to keep it for me because if I carried it, I might spend it, and it isn't mine." By the way, could he borrow a jacket and some gloves? Coleman parted with a pea coat and a sweater.[172]

Five hours later, Hecker was back in Portland, coming through the front door of the apartment he shared with Nellie Lainhart, twenty-four, an Imperial Hotel mail clerk, on Sixth and Montgomery Streets. Clad in a pea coat, not the gray number she'd remembered from the evening before, he met her with his customary charm ("He just came in like he always does, and smiled and said hello,"[173] she'd recall) before handing off an embrace of muddy laundry.[174]

"He said he had to go away right away," Lainhart later told police, "and I cooked his breakfast for him. We talked together while we ate, but he

offered no explanation for his absence…I didn't see him again after he left the apartment."[175]

Percy Johnson had all but surrendered hope that his buddy Ralph's brother would ever return the touring car he'd borrowed, supposedly for a simple east-side drive.[176] Johnson and Ralph Hecker had only weeks earlier established the Columbia Sales Company, headquartered in Portland's chamber of commerce building. (The duo, financed by their fathers,[177] peddled a gravity electric switch, "the perfect automatic safety device which prevents Fordson tractors from tipping backwards on driver.")[178] But around 9:00 a.m., guess who sauntered into Johnson's office with apologies aplenty? Everything was fine, Russell Hecker said. The machine was parked on Pine, right between Second and Third—roughly two blocks north.

Relieved, Johnson sent salesman F.A. Mitchell to retrieve it and drive it to a tire shop. Mitchell found the auto exactly where Hecker had said it would be, but something seemed wrong—terribly, suspiciously wrong. Maybe it was the new rubber mats up front. Or the cushions that seemed different, a little off, as if someone had gone to great pains to—

Blood

There was blood.

The interior. The running board. Even underneath the body.

Mitchell telephoned Johnson from the shop.

You need to get down here.

Now.[179]

Johnson wasn't the only one looking for his car. So were the Portland police, as it matched the description of a vehicle reported that morning by a man named Albert Bowker inquiring about his missing brother, Frank.

Albert had last seen Frank around 7:00 p.m. on Sunday at Broadway and Stark Streets, right before he skipped off with some kid to some liquor bounty in another part of Portland: fifteen to twenty cases, reportedly, at eighty-five dollars a pop. Frank knew the kid—they'd worked together at the Liberty, Bowker as a musician—but, like any smart rumrunner, he nurtured a protective distrust. Albert volunteered to tag along, but the young man forbade it. Instead, he'd meet them later, at Eighty-second and Division, about a half mile from this trove. Frank packed iron, so hopefully there'd be no surprises.[180]

Albert arrived at the rendezvous point at 8:00 p.m. The others never showed. No car, no booze and, worst of all, no Frank, gone with the $1,400 in cash he'd brought if the cachet proved legit. And when his brother hadn't filled his bed by morning, Albert knew the deal had gone sour.[181] Bristling,

he called the cops and told them everything, adding that that the only other person to see Frank alive was his driver and partner: Russell Hecker.

His captors kept him for hours, but it did them no good. Stubbornly, he deflected their questions and exhausted their patience, refusing to cooperate, as instructed by his attorney, Thomas G. Ryan. When he learned the authorities were looking for him, he'd willingly surrendered. Once in custody, Russell Hecker fell frustratingly mute.[182] "Hecker is a debonair youth," the *Morning Oregonian* reported. "He smoked cigarettes constantly while inspectors questioned him and examined his effects. Apparently he was amused at their activities."[183] Where was Frank Bowker? Silence. What happened in that car? Nothing, as far as they'd ever know. Only Leon Jenkins, described in *Portland's Finest, Past and Present* as "one of [the city's] most respected and well-liked chiefs of police," elicited any information, none of it useful. The most the suspect would reveal was "Bowker is not killed," "My attorney told me not to talk" and the cryptically exasperating "Things look a lot different now from what they may in a few days."[184]

Russell was more forthcoming with his father, who drove up from Albany. Barney relayed some of that exchange when he himself sat with Jenkins.

"How involved was your son in this incident?"

"Awfully bad," Barney replied.

"Was there anyone else with him?"

"I tried to get him to say there was, but he says, 'No.' Just think: he drove with that body within a block of our house in Albany, then——"

Words seemed to stockpile as Barney weighed their import.

"He turned around and went back to Portland."

"Where's the body?" Jenkins asked.

Barney aimed a shaky finger south.

"How far?"

"I guess about halfway between here and our home."

Barney suddenly reclaimed his resolve.

"But I've talked too much already," he said. "I won't say any more until I have seen my lawyer."[185]

Detectives and do-gooders tore up every inch down Pacific Highway, upturning dirt from Salem to Albany. Marshal Catlin cast nets from Albany to Jefferson but came home empty-handed. They weren't even close. Not only were they looking in the wrong region, but they were also thinking too conventionally. What no one knew—and the Heckers refused to be specific on this point—was that the body of Frank Bowker was neither carefully hidden nor entombed in solid earth.[186]

The Calapooia River at Albany in 2009. *M.O. Stevens.*

At 5:30 p.m. on Tuesday, April 18, a police car bearing Chief Jenkins, Multnomah County sheriff Roy Kendall (no apparent relation to our Charles) and Barney and Russell Hecker and their attorney, Thomas Ryan, came into Albany and traced the prisoner's route through town, coming to a stop over the Calapooia. Everyone turned to Russell, but only silence came. Sensing his son's hesitation, Barney stepped out of the car and walked toward the center of the bridge. "There's the place," he nodded, tapping a blood-webbed plank with his shoe. Russell had wrapped the corpse in a hop sack and dumped it over the rail. They were all standing over Frank Bowker's eternal bed: the devouring shroud of the Calapooia River.[187]

An express wagon brought back a rowboat and its crew: Sanford Archibald, Foley Swyter and Deputy Ellsworth Lillard. As Archibald steered, Swyter and Lillard trawled the water with hooks. Word had spread, summoning gawkers to the riverbanks and creating a network for Jenkins to squirm through to reach the bridge and shout to the men below, "He [Russell] says there were rocks enough in the sack to carry it right to the bottom."[188] The trio continued until nightfall to no avail. Hooks weren't going to work. This required a large-scale operation.[189]

At daybreak, the search resumed. Archibald returned with his rowboat, joined by John Feirstein, who drove his gas launch, the *Oregon*, up and down the river. Grappling irons arrived from Corvallis. Portland detectives Charles Klingensmith and Fred Mallett worked spectators for clues. Sheriff Charles Kendall, Marshal Catlin, district attorney L. Guy Lewelling and coroner E.C. Fisher were also on the scene. Both Heckers were back, although neither spoke with their attorney present; Ryan,

for his part, seldom left their company. Albert Bowker came down. Not everyone in town was accounted for: Ira Coleman had gone to Portland that day to surrender. The heat was too heavy. He pulled his deposit from the J.W. Cusick & Company bank and turned it in.[190]

Rumors weaved through the crowd. Russell Hecker didn't act alone. He didn't do this, couldn't have done this, had neither the strength nor the disposition to kill. Everyone in town who remembered the kid regarded him as nothing more than spoiled. What was it Nellie Lainhart told the cops? "Russell Hecker was a mother's boy. He wasn't brutal; there was nothing cruel about him. In fact, he was chickenhearted, I thought."[191] And didn't Marshal Catlin say something about a couple of weird strangers hanging around early Monday? One walked right into Price's Barber Shop with blood on his shirt and some guff about a pulled tooth. Another drove into the Highway Garage to have his sparkplugs cleaned. He'd gotten lost en route from Eugene to Portland and had been in the city all night. Maybe that was just his cover.[192]

And maybe, just maybe, Frank Bowker was alive.[193]

Activity moved from just under the bridge to the overhead Oregon Electric train trestle. By then, Portland grappler Hugh Grady had joined the party. No one found a body, just an old car seat.

The big-city contingent had gone home by the time the search wrapped but returned the next day to continue dragging the river—an effort that now carried a $200 reward, offered by Albert Bowker to anyone who found his brother's body and conduct interviews. Among the interrogators were Jenkins; Lieutenant Harvey Thatcher; Detectives Mallet, Klingensmith, Hall, Inskeep and Howell; deputy district attorney John Mowry; and court reporter George Begg.

They set up at the Hotel Albany, where young Mr. Hecker had registered in the wee hours not even a week earlier, and received witness after witness. Ira Coleman's wife confirmed that her husband had been on a fishing trip and didn't come home until 11:00 p.m. Mr. and Mrs. Ralph Crawford recollected a conversation with Mr. Coleman about Hecker's visit and the money (Ira supposed Russell had run a helluva bootleg number that night).

No further clues surfaced at the scene on Thursday, although Swyter found a blood-soaked handkerchief monogrammed with the letter "R," perhaps the same one Sheriff Kendall had noticed clinging to a snag the day before. Unfortunately, there was no link; the item belonged to R.A. Hudkins and had been tossed onto a tree stump.[194]

While weary parties combed the Calapooia, Hecker relaxed in his cell, smoking freely, poring through the Portland papers. He engaged reporters, who were all too willing to talk to him even if he couldn't be as generous. "I have found," he said, "that every time I have disregarded my father's advice, I got into a scrape of some kind. I promised him that I would follow the instructions of my attorney. I'm very sorry that I can't tell you anything about the case."[195]

At 7:00 a.m. Friday, April 21, John Feirstein informed Sheriff Kendall that after a day's rest, he was heading back to the river with his friend Pete Moench. Kendall, meanwhile, drove to Corvallis to return borrowed grappling irons.[196]

Feirstein fired up the *Oregon* and began puttering downriver. Around the east bank, he spotted a strange ripple coursing over a curious shape. Excited, he cast a hook and pulled the object to the surface, dragging it toward his boat. What he saw stopped his heart: a heavy burlap sack.

Bowker.

Feirstein and Moench quickly fastened their catch to the launch and pointed the *Oregon* toward the west bank. Feirstein leapt ashore and ran up to the bridge, where Jack Hammel waited with a car. Together they drove into Albany, first to the jail. No luck: Kendall was still in Corvallis. The coroner, however, responded, as did correspondents from the *Democrat*. Lewelling arrived moments later. He and Fisher examined the sack, with its large tear and loosened white twine. There was definitely a body inside: an older man, his hair fine and gray, his form crouched and folded, garbed in a gray raincoat and gray pants under a pair of gray overalls.

Feirstein pushed the *Oregon* four miles downstream, to the Bryant Park boathouse, where the body was removed, photographed and transported to the Fisher-Braden funeral parlor. Orders were given to wait for Portland officials, although Fisher, upon preliminary examination, found an exit wound over the man's left eye. He had likely been shot in the back of the head; death was instantaneous.

The University of Oregon's Dr. Robert Benson confirmed this in the autopsy, further stating that the corpse was carrying keys, telephone checks, dental floss and a pocketknife. No cash or further identification was found, but sitting inside one of the coat's pockets were nine live .38 bullets. Benson pressed one into the head wound. It fit, which meant that the decedent was killed with anything from a .38 to a .45, the type of pistol Hecker possessed that night (Bowker wasn't the only one armed), having borrowed it from Noble.[197]

By now, the body's identity was no longer anonymous; Albert Bowker handled that hours before the Portland crew arrived. The poor man

was indeed his late brother. With that established, only one real question remained, one whose answer would determine the venue of Russell Hecker's trial for first-degree murder:[198] where was Frank Bowker killed?

"There's the place," Barney Hecker had nodded, tapping a plank of the bridge with his shoe. There were other places, too. All you had to do was find and follow the blood.

You'd start sixty miles north, at the covered, wooden Baker's Bridge in an unincorporated thatch of Clackamas County (today it's called Damascus). A car came through around 7:00 p.m. on Sunday, April 16, and parked just off the Pacific Highway, in an area concealed by trees. A half hour later, along the Eighty-second Street road, near the Clackamas rifle range, residents Mr. and Mrs. L.A. Milner spotted an idling auto and heard a gunshot. A trail of blood materialized three hundred yards south, culminating in a rather impressive reservoir two hundred feet later. Farther south, along the Pacific Highway proper, detectives discovered two additional puddles and another telltale line spanning about one hundred feet. Interviewing local witness Grace Herbert, they learned that a touring car, beams aflame, engine engaged, had stopped here around 8:30 p.m. before resuming south. However, she noticed only one occupant.[199]

This solitary soul was next observed an hour later at a St. Paul service station near Horseshoe Lake, in Marion County. This time, he interacted with his witness, attendant C.H. O'Neill, who couldn't help but notice blood along the automobile's running board and, more alarmingly, on the man's own hands. Hotel Albany night clerk Clifford Westbrook would describe Hecker's demeanor as calm. But that came hours later. O'Neill met a different Hecker: nervous, numb, maybe even terrified.[200]

The matter was henceforth settled: the defendant would be tried in Oregon City, Clackamas County. District attorney (and future judge/Clackamas County Bar Association dean) Livy Stipp would represent the state's interests—he would be aided by special prosecutor Frank Lonergan and deputy district attorney George Mowry—while the Heckers retained the services of Gilbert Hedges and Gale S. Hill, the latter of whom had defended Carson "Pete" Beebe only five months earlier. Circuit judge James U. Campbell was selected to helm the bench.[201]

Albany secretly relished its role in what would prove the trial of the summer. In fact, at the end of April, when an eagle-eyed citizen found blood along the Willamette's banks, the town rang afire with fresh talk of murder.[202] The locale was a prime spot for ruffians with penchants for booze, pugilism and gunplay, so anything was possible.[203] Sheriff Kendall went to investigate; samples were extracted and sent to Portland. However, nothing more was ever reported.

MAY

It looks like the crime wave must come to an end.[204]

A curious item ran in the May 3 *Democrat*. Two months had passed since the fair-sex bullpen that heard *A.M. Templeton v. F.M. Franklin*, but the town wasn't finished luxuriating in its progressive afterglow. The headline clucked, "Woman Jurors Highly Praised," prefacing assessments from Judge Percy R. Kelly and district attorney L. Guy Lewelling. Both commended the female sex's efficiency, its willingness to forego the bonding foreplay of prattle to focus on matters at hand. Lewelling declared that women were "as a rule the equal of men in possessing intelligence…and in many cases are superior"[205]—quite a forward-thinking observation for 1922, less than two years after the Nineteenth Amendment was ratified.

Perhaps this puffery was spurred by the momentous if momentary appearance of Mrs. Z. Kathleen Ayers, a formidable San Francisco automobile enthusiast hell-bent on driving from her home city to Portland in one day's time. Her Buick coupe had blown through the previous day, and she'd stopped for a half hour—time to spare, apparently—to survey the showroom goods at the Murphy Motor Company. Then she waved her goodbyes and hit the road[206] (her spiritual sisters at the First Christian Church toiled over batter and irons, whipping up a waffle fundraiser).[207] Ayers was successful, completing the journey in twenty-two hours and thirty-four minutes. Not only did she establish a new record for the feat, but she also beat the Southern Pacific express train from the Bay by a good six hours.[208]

The automobile was transforming transportation, compacting the country into something less mysterious and more accessible. You could start in one state and then magically, by sundown, find yourself deep into another.

Meanwhile, Albany itself was expanding. Of the 24,500 citizens packed into Linn County, 5,000 called Albany home. Slashed through its heart were 10.1 miles of paved streets, 25.0 miles of cement sidewalks and 84,480 square yards of gravel. The city limits faded before Fifteenth and Ferry Streets, elbowing the east end of the Linn County Fairgrounds and Race Track. North of the grounds sat the tracks that comprised the train station and rail yard. Farther south: a painting in progress, a canvas dotted by lots and interlocked roads clasped like hands in prayer.[209]

Development elsewhere was a-boomin'. New homes and businesses erupted across the east side.[210] By the end of May, Albany would have a new Standard Oil Service station[211] and, more importantly, modern hospital facilities punched into the old Cottage Hotel on Fourth Street.[212] The project's backer and namesake, Dr. J.E. Bridgewater, buried the old floors under clinical linoleum and sculpted the interior into rooms and wards.[213] Albany High School readied graduation services for the 50-strong class of 1922, a 20-student drop from Clark Kendall's class the previous year but only a minor decline when considering the 107 juniors, 155 sophomores and 157 freshmen coming up through the system.[214]

The Ku Klux Klan continued to make aggressive inroads and struck publicly as the city remained gripped in Hecker fever. The Klan had booked the Globe Theater for Thursday, April 20, filling the evening with white-robed propaganda. First, the audience endured a Klan-supported motion picture (*The Ku Klux Klan Will Ride Again*, released by the Fox Film Co.) and then a lecture by Dr. Reuben Sawyer. Little was written of the film; it was Sawyer who brought the theatrics, beginning with his entrance. The Globe's stage was adorned on either end by an American flag and the cross, held together by an eight-man line of Knights in immaculate cloth. As Dr. Sawyer entered, they turned in perfect sync and saluted the flag, which Sawyer, falling to bended knee, took between his fingers and kissed. Then, with these very same lips, he unleashed some of the most politely expressed bigotry ever uttered in public. "You have read these stories and heard these reports," he announced. "Now we want you to hear our side. Then decide for yourself. This is all we ask."[215]

With that, he outlined the organization's credo and explained some common misunderstandings. The Klan didn't hate Catholics, per se; they just despised their unquenchable thirst for religious and political control. Japs

were fine, so long as they didn't get any funny ideas around white women. And membership was open to all who held Jesus and America in the highest regard, so basically everyone but Jews, blacks and the Knights of Columbus (i.e., Catholics).[216]

Naturally, the Knights of Columbus didn't care for Dr. Sawyer's speech. Dr. A.R. Mitchell, head of Albany Council No. 1557, responded immediately by issuing a $500 challenge to the Klan (the money to be donated to the local Red Cross),[217] demanding it devote its second evening at the Globe to a spirited debate. To ensure impartiality, Mitchell suggested that both groups appoint one non-Catholic judge apiece, who would then, together, select a third. In other words: support your outlandish assertions with facts. Failing that, shut your mouth.[218] The Klan, of course, did neither. It didn't have to. By then, it was too powerful to care, wielding more clout than even Ben W. Olcott, the state's own governor.

Their challenge unanswered, the Knights scheduled their own evening at the Globe two weeks later. On May 8, spectators surrendered fifty cents for the billed screen entertainment, plus an impassioned live appeal on the organization's behalf by Portland attorney Frank R. Lonergan. Lonergan rebuffed Reuben Sawyer's poisoned spiel before a capacity house, although his appearance didn't receive quite as much ink.[219]

A more raucous showcase debuted four days later in the form of the First Presbyterian Church Minstrels, under the direction of Reverend Poling. "See well-known Albany men in the black-face mimic art," barked advertisements splotched with cringe-worthy renderings. "It's a scream—a roar!"[220] Six hundred roarers (allegedly) crammed into the Globe to watch monkeyshines for Albany College's athletic fund. Performers were slathered in shoe polish and dress suits that, according to an anonymous *Democrat* hype-slinger, "would put the average traveling troupe out of commission in general appearance."[221]

One of these obscured countenances belonged to none other than Sheriff Kendall, certainly no stranger to the footlights and likely the bill's most seasoned performer. He figured in a pair of scenarios and delivered several monologues.[222] Although no program exists from the show, one can imagine him plucking Laura Alton Payne's "Youth" from his arsenal and bouncing it across the theater:

Sho' now! Me old at eighty!
Get shet of that idea
A hundred years ain't weighty

For a peartsome chap like me;
I'm ez frisky ez a ferret.
An' jolly—ain't I, Joe?
It's only the old in spirit
That's really old, ye know.[223]

As Albany's luminaries shucked and jived, Brownsville residents hoped to steer the county toward salvation with the establishment of the Good Citizenship League. Its formation was announced in the May 12 edition of the *Brownsville Times*, plastered beneath an item trumpeting a potential local Klan chapter.[224] (The *Times*, which did not support the KKK, flecked the piece in ridicule: "It has been suggested that they are going to enforce the traffic law while others think they are after the cigarettes while it has been suggested that the white robed figures will prevent the sale of ice cream on Sunday. Anyway, it looks like the crime wave must come to an end.")[225]

The league's mission was simple: to become nothing less than the county's moral conscience. Comprising its body were church leaders, WCTU members and other figures who, although never identified publicly, commanded enough respect to guarantee receptions with high-ranking officials.

The first salvo in its righteous war came May 19, when a subcommittee of Chairman Jim Fox, B.T. Kunsler, R.P. Daugherty, Mrs. A.M. McClain and Mrs. Charles Howe petitioned the Brownsville School Board to refrain from employing teachers who danced or attended functions where such temptation existed.[226] (It sounds ludicrous now, but this was an era in which an older generation denounced jazz—including the *Democrat*'s editor, who harbored a weird obsession with it—and lamented how the form's rhythms and libidinal gyrations bastardized dancing.) "We are confident," read the text, "that this requirement will materially assist in creating and conserving the better interests and influence of our schools, home and community life." The board unanimously rejected the suggestion.[227]

Undaunted, the league continued its push for purity, gathering advocates by the handful. (Within a week of its formation, the Good Citizenship League boasted sixty members.)[228] Its next announced event was a mid-June summit with district attorney L. Guy Lewelling and county sheriff Charles M. Kendall regarding the liquor laws.[229]

Kendall certainly had his hands full with that. On May 23, he responded to a call from a Mill City woman being beaten by her drunken husband. When the sheriff arrived, he confiscated the brew and then walked to the home of William May, its manufacturer. May wasn't around, but his wife

The Albany Steel Bridge (1892) extended across the Willamette River over what is now Monteith Riverpark. *Courtesy of the Albany Regional Museum.*

answered the door, resplendent in naïveté. When Kendall nonchalantly asked for a drink, she complied, apparently ignorant of her visitor's identity. She proved quite the hostess, even inviting him inside to marvel at her husband's gear and allowing him to use the telephone. The next evening, a deputy showed up and arrested William May. The prisoner was in court the following morning hemorrhaging $154.60 in fines, surrendering his still to the sheriff and promising to leave white lightning to God.[230]

Perhaps he may have benefited from the Reverend Healy's May 29 baccalaureate address to Albany High's outgoing seniors. All fifty students, plus parents, faculty and assorted relatives, packed into the First Presbyterian Church to hear Roy expound on diverging paths and fulfilling goals. An attending scribe hailed it as "a masterpiece in range of vision."[231]

The month of May ended on an eventful, if expensive, note when the Albany Steel Bridge, a long, rickety fossil stretched across the river's width from the end of Calapooia Street to the Albany/Corvallis Highway, caught fire—as it usually did—from the nearby burning of driftwood. Witnesses watched as flames flicked through slits in seams and planks.

The responding fire truck caromed wildly toward the scene, its hose cart in tow and weaving loose. As the truck bore down Second Street, the cart broke free near Broadalbin and, on its own momentum, cleared the curb and averted a head-on meeting with a telephone pole. Unfortunately, that pole was the last obstruction between the cart's reckless flight and the Baltimore Bicycle Shop's front window.

An explosive splash of glass added a touch more excitement to an evening already jammed with noise. And the cart kept going, twisting equipment, crushing inventory, shoving everything in its path toward the room's back wall. Finally, it stopped, leaning on a crippled wheel as if to admire its work.

Final damage: bridge fire, $100–$300; bicycle shop, $500–$1,000.[232]

JUNE 1–20

Papa, there's the man![233]

Estella Scott was Mrs. Charles Kendall, though that name hardly defined her. She was twenty-eight when they were married, older than many brides of her era, old enough to have already established herself as a schoolteacher in her Kansas township. As a mother, she ruled a classroom of one, instilling in her child a passion for literature and music, the finer things, plus a desire to excel in school—which Clark Kendall did, consistently, as his still-extant report cards attest.

An ardent lifelong writer, Estella produced volumes, her grammar, punctuation and script impeccable. Scraps of paper became platforms for poetry. The manufactured sentiment of greeting cards competed with her own, more genuine expressions. She may have been the sheriff's wife, ramrod straight and proper, but no one doubted her creative, indomitable spirit.

One of her few published pieces ran in the June 5 *Sunday Democrat*, on behalf of the Albany Garden Club (Estella was a member and gifted horticulturist in her own right). She praised local spreads in prosaic bouquets, reserving her finest arrangement for a "Mrs. Woodward," whose eastside home was pinned between Oak and Pine Streets, the Willamette River chortling placidly astride the lawn. "Her tulips are a glory," Estella enthused. "The eyes rest on the wild shrubbery on the slope of the bank to the blue river and the farther shore."[234]

About four blocks southwest, on Main Street, stood Calavan's Drug Store.[235] That very Sunday afternoon, eight-year-old Fanny Rodgers stopped

in to purchase mothballs for her father, who was helping a nearby friend move his household goods.

Inside, she met a man. She didn't know him, but he seemed nice enough. He talked her up, plied her with ice cream and told her about the cow he'd left tied at the riverbank, near the cannery. They were having such a good time; would she mind accompanying him? Fanny supposed it was all right, especially after he promised more ice cream, so they walked toward the river together.

As they got closer, houses became fewer, replaced by trees and brush. Main Street itself even ended, overtaken by nature. The Willamette gurgled just beyond. Otherwise, all was silent. There was no one here, no eyes to observe them and no raised voices to stop what happened when the very nice stranger became less friendly.

A.L. Rodgers struggled with his daughter's story. He'd sent her to the drugstore and she returned in hysterics, her clothes disheveled, her flesh pocked fresh with bruises. A man had tried to hurt her and gave her two nickels to buy her silence. But she told her father everything, and her father told the police.

Marshal Catlin took the call. Upon arriving at the scene, he deputized the elder Rodgers and his friend Ed Smith and then escorted the child through town, hoping to find this predator. Two hours yielded nothing. Then, at 4:30 p.m., as they patrolled the west end near Bryant Park, young Fanny sat up and excitedly cried, "Papa, there's the man!"[236]

They spotted him at the corner of Third and Calapooia. He couldn't have been more conspicuous, leaning to address another little girl. As he walked away, the three men piled out of the car and spread out, trapping him in a triangle. Catlin grabbed the bewildered suspect, who tried to wriggle free, only to confront his most recent victim's father. Weary of shenanigans, the marshal pulled his gat. Playtime was over.[237]

The man's name was Cloy Alvin Sloat.[238] He was thirty years old and in no way fit the prevailing "deviant" profile. Publicly, he carried the demeanor of a model citizen, with the background to match. He'd been a schoolteacher in communities throughout Oregon and that year had served as principal of the Oakville school just outside Albany. When its eighth graders graduated later that month, their certificates would bear his signature. So his protestations of innocence, his claims of mistaken identity, could very well prove to be true.

Unfortunately, he was stuck in the Linn County jail, and the history he'd quashed began to resurface. As Sloat cooled his heels, another local, Clarence

Magers, identified him as the man who'd assaulted his preadolescent daughter in the same part of town two weeks earlier. From there exploded a damning chain as other victims stepped forward.[239]

When cornered by district attorney L. Guy Lewelling, Sloat admitted to having been acquitted of a similar crime in Yamhill County.[240] Marion County authorities wanted him, too, for unspeakable acts committed in Salem's Bush Pasture. That city's police chief, Verdan Moffitt, escorted Sloat's young accusers to the Albany jailhouse. Yes, they confirmed: that's him.[241]

Sloat may have spilled about Yamhill, but he neglected to mention what had happened four years earlier, when he was a motorman in Tacoma, Washington. Yamhill ended in his favor, but Tacoma did not; he was sentenced to six months in the Pierce County jail. Sloat served only forty-seven days before being released for the sake of his widowed mother, Sarah, who dutifully visited her son in Albany but seemed to grow more despairing.[242]

On the evening of Monday, June 12, Sloat scribbled a request onto a sheet of paper and slipped it under the jail door. He wanted to speak with Sheriff Kendall.[243]

It would have to wait. That night, the lawman joined Lewelling at Brownsville's First Methodist Church for a summit with the Good Citizenship League. The men discussed effective ways to enforce the Volstead Act, easily the group's most pressing concern, as it believed the area lousy with moonshine. Lewelling admitted it wasn't easy but vowed that Linn County, supported by morals, would eventually prevail. Kendall echoed his colleague's statements and then, ever the showman, regaled the gathering with some of his favorite humorous readings.[244]

Kendall's mood was decidedly more somber when he met with Sloat the next morning. The prisoner admitted that everything was true. Yes, he had attacked Fanny Rodgers at the river, although he claimed to have only "handled" her, as he did all of his victims. He was also responsible for what happened to two girls just outside town. But he wanted Kendall to understand that the students at Oakville were never in danger. Somehow he could suppress his desires—his "disease," as he called it, inflamed by sudden spells—around children he knew. Otherwise, he couldn't help himself.[245]

Now he faced at least five counts and, potentially, life in prison. If someone didn't kill him first. Marion County hungered to eat him alive, and Linn County was eager to allow it. On Thursday, June 20, both of their dreams came true. Sloat was indicted in Salem on six counts: one for rape, two for

assault with intent to commit rape and three for crimes against nature. A deputy quickly left for Albany, chains at the ready. Lewelling assured *Democrat* readers that should the resulting sentence prove unsatisfactory, he'd drag the scoundrel back and bury him with the remaining charges, ensuring that no little girl would ever lay eyes on Cloy Alvin Sloat again.[246]

June 21 (Prelude)

If this is true, I must some day see Linn County.[247]

The *Democrat* ached with its usual fluff/meat balance. Off in Portland, sailors trawled the Willamette for a boatswain buddy who'd tumbled off the battleship *Connecticut*. They never found him, but they did hook a middle-aged corpse wrapped in rope and made heavy with iron bars— eerie shades of Russell Hecker.[248] Cloy Alvin Sloat arrived in Salem for his arraignment, as did county district attorney L. Guy Lewelling.[249]

Closer to home, local Democrats handpicked Halsey farmer Ed Zimmerman to run for county commissioner. Mrs. Archie Bilyeu took delivery on a new Hot Point electric toaster after winning the newspaper's weekly missing word competition. The Albany Chamber of Commerce entertained correspondence from a John Collier of Tucson, Arizona, whose good friend E.R. McDaniel, a Willamette Valley native with pioneer roots, often waxed rhapsodic of the area's natural beauty. 'Twas a patch of idyll so glorious, he swore, that Saint Peter had to build a separate space for its spirits, for once they crossed the Beyond, they found it wanting and demanded a return to their earthly homes. "If this is true," Collier sighed, "I must some day see Linn County."[250]

The newspaper also reported Estella Kendall's departure for Portland that morning with her son. Around that time, Sheriff Kendall was preparing to make the news himself, organizing warrants to serve in the name of the Volstead Act. It's unknown if his June 12 conference with the Good

Citizenship League precipitated this action, although some later claimed that a few names slipped loose in the heat of discussion—names of known offenders, all but one now lost to time.

THE FARMER

With all of this verbal Shellac, tinsel and veneer, you cannot fool us old-time hunters and trappers.[251]

As the Reverend Poling pondered his annual address in the January 1 *Sunday Democrat*, a Plainview man named Dave F. West set his own restless mind to paper. The result was a lacerating, if scattered, rebuke of a December 29 *Albany Democrat* article on monies paid for 1921 gaming licenses. It was a tremendous scam, West thought, enforced by fools appointed by criminals.

"It now develops," he observed,

> *that the Game Commission secured the passage of an act that…raised the Sportsman's license fee from $3 to $5…and whenever it fails to convict in its numerous game prosecutions, as they have in many instances, the taxpayers of the county are made the goat and stuck for the costs, and receive nothing from this Game Fund except pure bunk handed out by the commission and its incompetent deputies about conserving the game interests.*[252]

West was speaking from bitter experience, as he was only too happy to recount. In March of '21 he'd been arrested in Lane County for the unlawful possession of furs, and the scoundrels drained him of $300 in fines. Then, as if to compound his humiliation, they seized his traps and refused to return them. In retaliation, West filed for damages in Linn County Circuit Court

The only known photo of Dave West, late 1800s. *Courtesy of Gary and Ingrid Margason.*

against game warden A.E. Burghduff and his hapless gaggle and received not only his confiscated gear but also $101.50, plus an apology.[253]

In his torrent, the sixty-eight-year-old characterized himself as primarily a small farmer. But West was also of a dying breed. The frontier ways he'd held so sacred were surrendering to the twentieth century—their freedom constricted by laws, their bucolic idyll razed by encroaching cities. It was getting to where a man had no rights at all.

He'd built his reputation in another trade, one he still indulged in winter. It had kept him flush in better years, when the country swam in unruly wilderness and towns were villages of mud-tromped roads. With undeniable skill, he'd hunted and trapped his way west from his home state of Indiana,

where he was born on February 21, 1853, in Boone County, so named for frontiersman Daniel Boone, a fact that may have pleased him.[254] West was something of a legend, too, known around Plainview as a crack shot, his eyes true down the barrel of his .32-caliber Remington rifle. He'd never enjoy Boone's acclaim, but knowing his neighbors were likely to keep a respectful distance was probably good enough.

Age hadn't dulled his vision, nor had it lengthened his fuse. His devoted wife, Ellen—some called her "Ella"—later described him as "awfully high tempered and determined,"[255] a volatile concoction that sparked a handful of hot-tongued yarns. Allen Parker, whose family has owned the West property since 1939, heard them all as a kid. At eighty-three, he recalled them vividly, chuckling at their mad color. Like the time the old man rented land from Warren Tripp, his neighbor to the east, to harvest oats for his cows in return for a third of the bounty. To make a long story short, West reneged. And when Tripp confronted him with a barrage of accusations, he happened to notice the size of Dave West's hands, his massive fingers coiling into fists. Tripp wisely retired his lecture and beat a hasty retreat. Any caller, stranger or otherwise, could be met at the front door by a pistol, its owner at the other end growling, "No one's gonna fall on me." In the face of such stories, the tenant West allegedly chased from his property with curses and a club over some perceived offense got off lucky.[256]

West had purchased the 39.16 acres in April 1911 from D.H. Duncan and his wife, Lou.[257] This acreage covered what was formerly the northeast corner of Section 1 in a four-part, 643.00-acre parcel deeded to Thomas M. Ward in 1847, upon his arrival from Des Moines, Iowa, with his wife and two children.[258] The centerpiece of this impressive expanse was a tree-pricked hill that would come to be known as Ward's Butte. Seventy-five years later, his descendants were still in the area; one of West's neighbors, in fact, was Anna Bonar, daughter of the Wards' first son, Scott.[259]

It was the Wests' second home in Plainview, where they settled after leaving Indiana in the late 1880s. The couple lived in a weather-beaten, two-story, T-shaped clapboard house. Its exterior may have been painted white once and then never touched again. An enclosed front porch overlooked the end of a private road. A long, wavering walkway protruded from this lane like a supporting limb, its length followed by a dividing fence, then curved toward a gate granting back-porch access.

To the house's immediate left sat a chicken coop and woodshed, base for another of the farmer's hobbies: moonshining. The operation was hardly covert—everyone for miles knew about it, and a passing whiff removed all

doubt. West used some of this brew in a homemade liniment, and the rest he apparently kept for himself. No one has ever established that he profited from its distribution, nor was it believed that he manufactured it in abundance (though local gadflies cracked that West and his wife must have suffered from the world's worst rheumatism). Farther to the left, about 150 feet from the house, two cows regularly called from a barn.[260]

When the Wests first came, they brought Ellen's two teenaged children from her marriage to the late John Pearce, or Pierce.[261] By 1922, both were adults with their own growing families. Daughter Sarah had married a man named Thomas Brandon and moved to far-off Condon; son George stuck around, living on a nearby farm. Various members of Ellen's clan, the DeAtleys, were frequent visitors; West's sole local relative was a sister, Mary Margason.

There wasn't much to Plainview even then. The railroad town had started small and was only getting smaller. Its post office had shuttered sixteen years earlier, all correspondence redirected west to Shedd.[262] Older folks likely remembered days of blacksmiths and stockyards and modest local enterprise. Now the community contended with a new age, its dusty roads anathema to regular automobile traffic, its location apart and isolated, a good fifteen miles from Albany, the nearest Linn County hub of note. Eventually, only the name remained, attached to a community hall and main street and to the tongues of its longtime residents. Families left. Homes and farms were crushed and cleared, cleanly erased from the landscape. Sheltering trees ached alone. Some fifty years later, historian Floyd Mullen would write, "Now it cannot be called a ghost town because the town is no longer there; it is a wide place in the country road at a railroad crossing."[263]

"The character of the country has changed in my lifetime," Allen Parker told me, somewhat wistfully. Although he and his wife, Phyllis, have long since retired to Visalia, California, he returns once a year to check on his properties, staying with his sister Louise in nearby Sand Ridge. "It's about five miles down the road. In that span we counted nine places where there used to be buildings and farms. Now it's just great big fields."[264]

Plainview's moment had passed.

Dave West, however, wouldn't go so quietly.

June 21 (Afternoon)

It would be all right if they came here like gentlemen,
but they can't break things up.[265]

From what I've gathered, ninety-plus years after the fact, Dave West and Sheriff Kendall were on cordial terms. While they wouldn't have tackled an afternoon swapping stories, they got along—a textbook lawman/ layman relationship. But then, Kendall was easy to like. West, on the other hand, was a tougher egg, although neighbor George Washington Manning enjoyed his company. "Dave West was a good friend," Manning's grandson Wendell told me in 2013. "He made moonshine, and granddad liked moonshine. He said that Dave made it for himself and his friends. He just minded his own business, set in his ways."

I've often wondered if Kendall, a frequent visitor to that edge of the county, knew of West's side pursuit but considered its scale unworthy of bother. Yes, Kendall was the sheriff, but he was a peacekeeper, too. These were his people; they had to trust him. Why visit the law's full force on folks just getting by? Dave West wasn't some crate-smuggling bootlegger, just a farmer whipping up swigs between rheumatism remedies. One can imagine an unspoken arrangement: stay out of trouble, and trouble won't come.

But in the early afternoon of Wednesday, June 21, 1922, it was well on its way.

No one truly knows why the Reverend Healy joined Kendall that day. Some say for the ride, others for the pleasure of the sheriff's fellowship. The newspaper claimed he was researching a book on liquor law enforcement, and

what better way than to watch it in action?[266] (The Good Citizenship League counted clergymen among its ranks; Healy was likely a member and, having an apparent interest in the subject, present at the meeting with Kendall and Lewelling.) Growing up, Wendell Manning heard another explanation entirely: that the minister had lodged a complaint against West—whether they actually knew of each other remains conjecture—and insisted, over the sheriff's dissuasions, on witnessing the arrest himself. Later generations passed other tales around; the tangiest involves a sting operation, 1920s style, in which Healy visits West under the pretense of purchasing medicine for his "ailing" wife, and oh, ho, ho, surprise!

Dave West lived sixteen miles south of the jailhouse. Using Highways 34 and 20 and Interstate 5, you can make that trip today in less than half an hour. In 1922, with only one real highway—Pacific (the route Albanyites know as Pacific Boulevard/Highway 99E)—into a winding series of rough roads swallowed by picturesque hills, it took a while longer.[267]

The men arrived to a lively scene shortly after 3:00 p.m. Ellen West's nephew Harry DeAtley had brought his wife, Myrtle,[268] and two children—Helen, six, and Argyol, four (he later went by "Tom")[269]—for an extended stay while he worked the Mannings' hay harvest. Helen and Argyol frolicked in the yard with the Wests' grandson, George Washington Pierce, eight, and four other kids from neighboring farms. Ellen and Myrtle were in the house. Dave was outside working as Kendall and Healy came to the front door.

Exact details get sketchy from here. Ellen West recalled that the sheriff asked her point-blank if she had any liquor. She protested her ignorance and then remembered a small liniment bottle and gave it to Kendall, who opened it, passed it under his nose and handed it back. No, he said. He meant moonshine.[270]

At this point, Dave West entered the house, perturbed that the sheriff was interrogating his wife. It looked like harassment to him, an outrageous display of disrespect. The three men took the discussion into the kitchen, where the farmer revealed the location of the still in the woodshed and implored, "Take it into Albany, but don't destroy the property." According to the *Brownsville Times*, Kendall replied, "You are an old fool for doing anything like this" and then set out for the woodshed.[271] (The Broughtons dispute this account, as well as any suggestion that the sheriff used his power to intimidate a woman; Wendell Manning heard that the exchange was more diplomatic, with Kendall assuring West, "Come with me to Albany. I'll book you and bring you back.")

This alleged admonishment, coupled with the lawman's nerve to ransack his home with search warrants and a preacher, punched all the wrong

buttons in old Dave West. "I cannot stand it!"[272] he cried, growing angrier and angrier until his temper consumed him and left him no choice but to grab his Remington and head outside to give these high-and-mighty "guests" a piece of his mind. The women tried to stop him, begged him not to go, but he shrugged them off and ordered them back into the house. "It would be all right if they came here like gentlemen," he argued, "but they can't break things up." Children were gathered, neighbors shooed home.[273]

Kendall and Healy had left through the front door, as it was closest to the woodshed. West had likely gone out the side, making sure he wasn't noticed as he slipped out of sight behind or within one of the other buildings, probably the barn. He observed from his hiding place as Kendall made his way back, setting two bottles of moonshine near the gate. Healy walked toward the property's south side. West moved into position and quietly brought his rifle in line, taking aim at his most immediate threat.[274]

Kendall had reached the side-yard path when a sharp crack rattled the country silence and an even sharper sting drilled through his left shoulder, punched him off his gait, punctured his heart and filled his mind with darkness. The sheriff fell forward. His hat tumbled, too, and came to rest nearby. Neither would move again.[275]

Healy turned at the sound of gunfire and saw the only armed man he knew lying facedown in the turf, weapon still holstered, taken unaware. With an echo that bowled down the valley, he had no idea where the sound originated, but he understood his life was in serious peril. He sprinted frantically toward the south, shouting into the indifferent horizon, "Somebody phone! They've shot Kendall!"[276] Then he took off back across the side yard, back to the car, back to the road, back to a neighbor, any neighbor, who'd deliver him from harm. Ellen West watched from inside as he passed the windows. Dave West watched him, too, and when he saw his opportunity, he raised his rifle one last time.

Myrtle DeAtley heard the shot while taking her children upstairs. Startled, she retreated and saw the minister through an upstairs window. He'd made it to the lane just off the porch. Then another blast came. If the first had missed, the second did not. Healy vanished from sight, falling hard into the lawn.[277] What pain he felt was too hot to last. Everything slipped away quickly—memories of his congregation, his family, his daughter, his wife, with whom he'd observed his eleventh anniversary the evening before—followed by the arrival of light.

A light. A stage. Could have been anywhere. Years ago, years from now. Charles M. Kendall looked dapper in his "Professor" guise: black suit, white

The Reverend Roy Healy died along this stretch of road east of Ward's Butte in Shedd, formerly known as Plainview. *Mark Ylen*, Albany Democrat-Herald, *2014.*

bowtie, expansive repertoire at his command. This one always got 'em: Willa Lloyd Jackson's "Enemies at Death's Door," the story of two soldiers on opposite sides of the Civil War finding comfort in each other as they draw their final breaths. It was so magnificent, so poetic, so eloquently rendered in the Kendall pentameter that no audience could help but be moved.

"The battle was over and the sun had gone down," Kendall began, and he could feel those souls in the dark leaning closer. "The dense white smoke of the great cannons had been dispersed by the evening breeze that crept faint and sweet from the dark woods nearby, lifting with touch as light as a living hand's the damp hair on icy foreheads, and fluttering in sad mockery the torn and bloody flag yet grasped by a hand forever still."

He continued with this tale of two men confessing their fears of dying, of surrendering even the simplest of pleasures, of leaving everyone they loved. He stepped forward, hands clasped behind his back.

> *And so upon the golden stars the foemen gazed and talked of home in tender reminiscence till, as the stars faded before the moon, climbing higher and higher in the clear dome above them, there fell a silence that was the benediction of a pitying God upon his wandering wounded children.*
>
> *And when the morning came, the busy surgeons and those who searched the field for missing friends came upon a strange, pathetic sight.*

The two that lay beneath the green oak's spreading boughs with death's solemn seal on their quiet faces were clasping hands blue and gray forgotten in the old, old bond of common brotherhood.

Kendall let the silence settle. The audience needed it, to digest the monologue's depth, and then responded with an emotional explosion of applause. He spotted Estella and Clark among the swarm, proud and supportive as they'd always been, the best sounding boards he'd ever known. He acknowledged the reception with a silent "thank you." Eyes that said, "I love you" to the two who mattered most.

He lingered for a moment. And then he was gone.

June 21 (The Aftermath)

My God, Uncle Dave, what have you done?[278]

Ellen West picked up the phone, an act that would bring the whole county to her door. She connected with Anna and David Bonar at the Plainview store, which served as the town's primary switchboard and message center. Someone, she said, needed to drive out to the Manning farm (the Mannings wouldn't have a telephone until the 1940s),[279] find Harry DeAtley and demand he come home at once. Ellen revealed nothing more than that.[280]

Harry didn't grasp the urgency of his aunt's request until he pulled from the road into the long, lumpy driveway. As his car approached the house, he spotted another automobile and a weirdly contorted obstruction beside it—clothes? An animal? No, to his horror as he got closer, a human body. There was another one as well, on the property's east side, resting just past the fence's gate. What the hell had happened here?

Inside, Dave West was surprisingly calm for someone who'd killed two men. Or maybe it was the demeanor of someone who'd already determined his next step. Harry was the opposite, horrified, aghast. He approached the old man as he sat in his chair, pistol and rifle ready for anything. "My God, Uncle Dave," he gasped, "what have you done?"[281]

West regarded his nephew and replied, "Yes, I'm in trouble. But don't worry. They'll never get me." Then he outlined the next course of action. Harry would call the coroner with specific instructions: Bring one man—

and one man only—to help retrieve the bodies. Any deviation from this request would result in further tragedy. And make it understood to all that he, Dave West, had acted alone.[282]

"I was dazed," Harry DeAtley later told the *Brownsville Times*. "I did not know what to think or do. I stayed at the place a few minutes longer and left for Plainview, where I announced what happened."[283]

Ellen West remained with her husband. They would end this day as they did any other. Dave would finish his chores, and Ellen would fix his supper. With the DeAtleys gone to Plainview, the Wests had maybe an hour or so together before their clapboard domicile was overrun. The couple attempted a domestic normalcy—Ellen couldn't eat, so she sipped coffee instead, primarily to appease her husband—all while knowing that after this meal, they'd never see each other again.[284]

Naturally, they talked about what would come. If Dave West surrendered, he'd get the gallows for sure, assuming he'd survive to stand trial or even leave the property on his own feet. He knew only one way out, and she need not be around for that. But this was her home, where they'd raised her children and built their twilight, and it would continue to be her home. He promised he wouldn't undo its history by fulfilling this final act inside the house.

"Goodbye forever," said Dave West. "This will be our last goodbye. After what has happened, there is nothing else for me to do."[285]

"I left at about six o'clock for the home of my son," Ellen West later told reporters, "and know nothing of what took place thereafter, but was sure my husband would do as he said."[286]

Harry DeAtley took his family straight from the West house to the Manning farm, where he told G.W. everything. Together they went to the Plainview store, and G.W. made the call to the coroner. Bring a man down, but one man only. Fisher in turn recruited the best man he knew: district attorney L. Guy Lewelling, likely exhausted from a day in Salem but reenergized by the death of his colleague.[287]

As they prepared to leave, they were collared by a curious *Democrat* reporter, whose innocuous query became a hot scoop and forced the newspaper staff to reassemble, tear apart the afternoon's front-page plate and prepare a second run, with editors waiting by telephones. The *Albany Herald*'s E.M. Reagan would soon be on his way, and as the news spread, so would Willard Marks (*Oregonian*), Fred Lockley (*Oregon Journal*), Charles Alexander (*Sunday Democrat*) and Jesse Hinman and Everett Earle Standard (*Brownsville Times*). The *Democrat* would distribute 1,800 copies of an evening edition,[288] front-

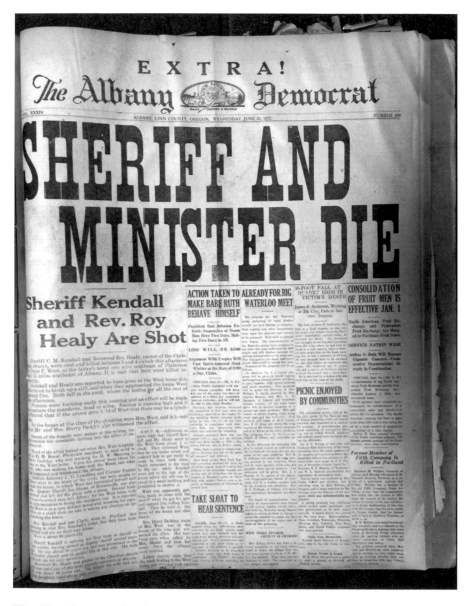

The *Albany Democrat* printed 1,800 copies of an extra evening edition on Wednesday, June 21, 1922. *Mark Ylen*, Albany Democrat-Herald, *2014.*

page headline emblazoned at an impossible size atop a rapidly drafted, error-riddled story: "SHERIFF AND MINISTER DIE."[289]

Of course, news of such weight didn't need journalism to spread. Estella and Clark Kendall had been notified and were on their way home by train.[290] Ada

Healy sought comfort in her daughter, her family and her husband's church. The evening sun lolled over long processions of automobiles from all over the valley, every one aimed at this tiny burg—cars packed with the morbidly curious and excitable men with guns. George Manning advised cooler heads amidst the vigilantes, knowing Dave West as well as he did. You may have strength in numbers, he said, but the old man'll drop you just the same.[291]

Once he arrived, Lewelling took charge. He told Fisher to stay back, lest West change his mind. Fisher, no fool, had no inclination to tempt a sharpshooter. The bodies of Sheriff Kendall and the Reverend Healy would have to wait.

Lewelling had tried to contact the governor's office to plead for reinforcements, but Olcott was unavailable. So he began the laborious process of organizing his own militia from various spare parts: neighbors, policemen, journalists and anyone who happened to own a weapon. The unarmed were turned away, banished to the swarms observing the property from a comfortable distance.[292]

In a rare display of journalistic harmony, the *Oregon Journal*'s Fred Lockley had hitched a ride to the scene with the *Albany Herald*'s E.M. Reagan. Neither had trouble getting in, but gathering information proved a hassle, so Lockley, joined by the *Brownsville Times*' Jesse Hinman, wandered down the lane to the home of George Pierce, where Ellen West was surrounded by immediate family (the DeAtleys, however, were at the Mannings'), ex–Linn County sheriff Delevan Smith (who'd first appointed Kendall as a deputy sheriff eleven years earlier) and Brownsville attorney A.A. Tussing. The reporters were introduced to the grieving spouse, who collected herself and told her story.[293]

"If my husband is still living," she said,

> I will trust you not to use what I say against him. We have lived in this county for 36 years. We have farmed on this place for the last 11 years… My husband and I were both born in Indiana. He is 69 years old. He is very good around the home but awfully high tempered and determined. I hope you will not blame me for this, and don't make it any worse than you have to for my husband.[294]

Once back at the scene, the newspapermen learned that Lewelling had deputized Reagan into a group plotting to surround the house. Lockley then joined *Sunday Democrat* editor Charles Alexander at the Manning farm, where they each took down Myrtle DeAtley's account. Upon their return, they were escorted by Reagan to the West home itself. The sun was gone;

night had cast its pall, and as far as everyone knew, the old man was holed up waiting for a clean shot or, worse, had escaped to Lone Tree Butte, where his skills as a hunter would put him beyond reach.[295]

The trio watched the road unfold in the glow of Reagan's headlights until a sentry stopped them and asked them to kill their beams. The car rolled to a cautious stop when they were approached again and told to join a bank of car spotlights pointed toward the house. Men were moving into position, ready to storm the porch. By now it was 10:30 p.m., seven hours after the shots that had killed Charles Kendall and Roy Healy, who remained where they'd fallen. "Look out," someone hissed. "One of the men is lying in the road." He pointed to the form that was once Reverend Healy, "his white collar crimsoned with blood," Lockley wrote. "Leaving the car, we approached the back door and were warned again to look out and not step upon the body of Sheriff Kendall, which lay face down with its head toward the house."[296]

Fortified by late-night courage and exasperation, one of the posse members crushed the kitchen window and slipped inside. Out front, another group breached the enclosed porch's door, lit a pair of found lanterns and cautiously toured the otherwise dark house, spotlights spearing walls, shouts from the outside calling for updates. A frantic Lewelling fretted that Delevan Smith, sequestered behind a hedgerow, might fire on an innocent shadow moving through the space.[297] But nothing happened. The invaders—among them Ellsworth Lillard, Jesse Hinman and Clarence Collins—emerged unscathed. The house was empty. No Dave West.[298]

The search intensified to cover the rest of the property. First they pillaged the woodshed. Then a voice crowed, "Throw your spotlights on the barn!" and soon a path was lit.[299] A group of men carefully advanced, rifles and pistols drawn. The door was open; someone had already gained entry and was rummaging about inside. At considerable risk, nineteen-year-old Alton Williams treaded alone through the building, stepping softly to avoid detection. If Dave West was alive—and here—this could very well be the kid's last mistake.

He continued toward the southwest corner, finger rested on the trigger of his rifle, when suddenly he hit something solid and his legs buckled, sending him into the dirt. Williams sat up and quickly retreated, having come face-to-face with Dave West. The old man's rifle slept in his grip, no longer a threat to anyone. He had taken his last shot. True to his reputation, he didn't miss.[300]

"Here he is!" Williams shouted as backup entered the barn. A posse member tipped his head out the door and called out to the others, "Unload your guns, boys. West is here, dead."[301]

A collapsed barn is all that remains of the West property. *Mark Ylen*, Albany Democrat-Herald, *2011.*

The ordeal was over. Excitement abated. Spectators dispersed. Cars disappeared. Fisher collected the bodies. Journalists left to file longer stories, their diets whetted by cigars from the Plainview store (out of stock by the end of the night), where they each waited by the switchboard to report details.[302] But not before a batch of officials materialized right on time: i.e., too late.

"After the bodies had been removed," Alexander recalled, "Warden J.W. Lewis of the state penitentiary at Salem, accompanied by P.M. Varner, state parole officer, Roy Kendall, guard, 'Cherokee' James, keeper, Joe Wright and Frank Rogers, guards, and Deputy Sheriff Sam Burkhart of Salem arrived upon the scene, ready for a stiff battle armed to the teeth."[303]

REST IN PEACE

Sheriff Kendall was a friend of every man he knew.
We are poorer today with his loss, yet we are rich with the memory of him.[304]

What you've read of this tragedy comes from testimony offered by its only adult survivors: Myrtle DeAtley and Ellen West. (West was interviewed by reporters at least twice, first at the home of her son on the evening of the murder, then again two days later while recuperating at the Bridgewater Hospital.)[305] Both are suspect, of course; as a relative by marriage, DeAtley may be unreliable, and Ellen was likely inclined to smooth her husband's rough edges.

L. Guy Lewelling proved her most vocal critic. He couldn't reconcile her story with the man he knew. Kendall, he claimed, would never have bullied a woman, and as an eleven-year veteran of the sheriff's department, he wouldn't have left a suspect—a volatile one, no less—to wander as he pleased.

He believed no confrontation took place before the murder because the men involved never actually spoke. Instead, Dave West, upon seeing his guests, made himself scarce. Kendall and Healy were, in fact, leaving when the farmer ambushed them. Furthermore, West had no cause to bemoan property destruction; no one had touched his still. According to Lewelling, revenue men found it intact and securely locked inside the woodshed.[306]

State parole officer Percy M. Varner, among the Salem cavalry that pulled in just as the Linn faction departed, told a different story, one featuring elements consistent with the version Wendell Manning told me. The clash

over moonshine actually did occur; Dave West wasn't slinking around his property like an assassin. Instead, he played to Kendall's sympathy. Let me go inside, he said. Get my coat, say goodbye to my wife. Kendall and Healy stood together near the gate as their prisoner returned to the house. He came back out on the front porch, blasting. Contradicting the Albany papers, Varner claimed Kendall was shot just below the heart and Healy in the back as he ran to the car.

"When we arrived at the house last night," Varner said, "we found a miniature arsenal in a shed just off the porch from where West did the shooting. In the shed were two rifles and a shot gun beside the rifle used in the killing."[307]

The resulting truth, nevertheless, was that three men were dead, three families and more were devastated and a community fell into grief. "Albany has gained an unenviable reputation as a crime center, through the number of tragedies that have taken place in this city," lamented a *Democrat* editorial. "It is hoped that it will be many years before the press of the state broadcasts the news of any more murders or terrible crimes."[308]

When Fisher took the bodies back to Albany, Dr. J.H. Robnett quickly ruled that all three died of gunshot wounds.[309] Fisher listed on his report, completed that very evening, that West killed Kendall and Healy and then added in a longer note:

> *I have examined into the cause of manner of death of Dave West—age about 69 yrs.—and deem it unnecessary to hold an inquest. The deceased was a native of Indiana and died in this county at Plainview.*
> *The cause of death in my opinion was—suicide—he shot himself.*[310]

Case closed. The town had suffered enough.

United in death and print, the men were separated forever Friday morning when a hearse transported Healy from the Fisher-Braden Funeral Home to Eugene at his family's behest. His funeral took place at 2:30 p.m. at the First Christian Church;[311] a church newsletter reported, "The main auditorium was filled, showing the high esteem in which Brother Healy was held." He would have been pleased at the turnout and at all the illustrious names from his past coming to pay their respects. Eugene Bible University president E.C. Anderson presided over the service, and professors V.E. Hovan and S.E. Childers each read passages from Scripture. Healy was buried at the Odd Fellows Cemetery (now the Eugene Pioneer Cemetery) under the simplest, most comforting of epitaphs for a man of the cloth: "With Jesus."[312] His

widow, Ada, and young daughter, Eleanor, spent a few weeks with relatives in Coburg, then left the mid-valley to begin anew in Eugene.[313]

Dave West was buried that Sunday at the Sandridge Cemetery in Lebanon[314]—interestingly, as it happens, less than five miles from where the Reverend Healy was born. Today, his stone is scarred with moss and faded from the elements. Jumbles of lawn partially obscure his epitaph: "Here rests a woodman of the world."[315] Sixteen years and two days earlier, he'd signed his last will and testament, leaving his every possession to his "beloved wife."[316] Neither suspected that the end would come so soon, so violently.

Saturday, June 24, was Kendall's day. Every store in Linn County closed in his honor.[317] Hundreds passed through the First Methodist Church to view his body in state. His funeral began at 2:30 p.m. A church quartet sang his praises, although his own fine voice was conspicuously missing. Estella and Clark Kendall wept in the front pew as the Reverend J.C. Spencer cleared his throat. "Though I walk through the valley of the shadow of death," he began, quoting the oft-quoted Psalm 23:4, "I fear no evil, for thy rod and thy staff comfort me."[318]

But his next words were entirely his own—an angry, fiery flood—and no one who heard them forgot them.

"There are probably many in this audience who have violated the prohibition laws," he said.

> *Many of you, perhaps, have patronized the bootlegger or the moonshiner. You who are guilty should hang your heads in shame, for you are not without a share of blame for the tragedy that has robbed Linn County of one of its best men.*
>
> *You, too, who have remained passive and indifferent to flagrant violations of the liquor laws are far from guiltless. If you have knowingly permitted the laws' violation you have in part contributed to the assassination of Sheriff Kendall.*
>
> *In the face of a lack of cooperation, and in fact hampered even by self-respecting citizens, Sheriff Kendall fought a hard fight against the liquor traffic. Often, he stood alone. The miracle is that there are not more numerous outrages such as that in Plainview.*

He regarded Estella Kendall and continued:

> *I feel that Mrs. Kendall would like to have me tell you—and feel this also in my own heart—that the day must never come when the service of this man shall be forgotten.*

Last Sunday, Sheriff Kendall in this church took part in a service that dedicated an American flag, the gift of the church to the Sunday school…One of the songs that day was "The Old Flag Shall Never Touch the Ground."

And so it was with the sheriff. He sacrificed his life upon the altar of his country that his flag might not become polluted with filth, just as so many of our soldier boys did on the battlefields of France. He died on his line of duty.

Sheriff Kendall was a friend of every man he knew. We are poorer today with his loss, yet we are rich with the memory of him.[319]

Kendall's friend Dr. Poling spoke next:

It is the duty of every man in Linn County to stand up for the law, and in so doing he must do his share toward its enforcement. Without the cooperation of the people, no law can be effective, for public sentiment is the law, and makes the law. If the majority, which constitutes public sentiment, remains inert, then the minority who are lawless shall negate the law.

There should be no argument, no hesitancy and no compromise. Could the spirit of Sheriff Kendall but speak here today I have no doubt that among his words would be these: If you men of Albany and Linn County break faith with me, I cannot sleep.[320]

Mourners packed Riverside Cemetery for the funeral. Kendall was accorded a place of honor, in Row 12W, where he has kept silent watch over his town as it's grown. A fence lines the property's width just behind his marker, separating it from the Masonic grounds next door. His placement no doubt was symbolic.

No one would ever take him by surprise again.

A NEW SHERIFF IN TOWN

[I]t was deemed wise to select a neutral who represents no faction and yet who may prove satisfactory to all.[321]

After Kendall was laid to rest, Linn County wrestled with the conundrum of an interim successor. Delevan Smith was good, a storied sheriff and deputy—and his actions in Plainview had returned him to awareness—but he was finished. Also in the running: Frank Richard, Lebanon's former police chief turned county deputy, and venerated local/Spanish-American War veteran Frank Stellmacher. Upon hearing such scuttlebutt, Stellmacher excused himself from contention. The court considered hosts of hopefuls, voluntary and otherwise (someone even lobbied for Estella Kendall, likely to her horror), but few apparently significant enough to warrant reportage.[322]

Nearly a week after the incident at Plainview, on Monday, June 26, the court appointed a new sheriff. The selection was as shocking as it was bold: William J. Dunlap. Although his wasn't an unfamiliar name, and he was considered a capable fellow, the thirty-nine-year-old had more in common with Dave West than Charles M. Kendall. He was a farmer, not a cop. His predecessor may have lacked experience when he joined the force in his forties, but he worked for a decade to earn the star. Dunlap had never been a uniformed officer anywhere; he'd lived most of his life on his family's land. An *Oregonian* editorial later described him as "just plain Bill Dunlap, who tilled his acres, loved his community and was at peace with the world."[323]

He was born on January 10, 1883, in Greenfield, Missouri, missing the town's incorporation by a scant seven years. By the time he came along, his parents were old hands in the child-rearing business. William brought up the end of a five-sibling brood and, besides father James, was the only other male in the house. He was closest in age to his sister Mary, a good half decade his senior. Eldest daughter Eleanor was fifteen when he was born, practically an adult.[324]

Yet all made the journey west in 1891, where the family bought property in little Shedd, Oregon.[325] Three of William's sisters—Almeda, Margaret (later to be affiliated with the Good Citizenship League) and Eleanor—wasted little time attaching the Dunlap name to a thriving enterprise. They pooled their finances to purchase the Crandall Drug Store in Brownsville and transformed it into the Dunlap Drug Company.[326]

William honored the family, too, albeit in his own way. While enrolled at Oregon Agricultural College, he became a vital cog in its football program. He played through his senior season, 1907, which happened to be the year of the team's singular athletic achievement, one unlikely ever to be duplicated.[327]

Head coach Fred Norcross had already captured local hearts with his inaugural season in 1906, leading the Aggies to a 4-1-2 conference record and allowing only four points overall. His acumen could be attributed to his age: he wasn't far removed from his own glories, when, as quarterback for the University of Michigan, he'd marched his Wolverines into back-to-back national championships in 1903 and 1904.

At twenty-three, he was younger than some of his players—including Dunlap, a stellar left guard—but to their benefit they listened and together

William Dunlap, in his younger days, played left guard for the Oregon Agricultural College football team. He stands fifth from left, back row. *OSU Special Collections & Archives Research Center.*

composed an impenetrable force. Not only did OAC emerge undefeated at season's end, swamping colleges and destroying clubs, but not one opponent left the field having scored a single point.[328]

That would assuredly change when the Aggies faced the favored and number-eleven-ranked St. Vincent's of Los Angeles (now Loyola Marymount University) for the Pacific Coast title. The big city could only overwhelm the dirty rubes from Oregon, send them yelping back home to suck on their cornpone. Newspapers predicted metropolitan domination. But that wasn't the case. OAC bent St. Vincent's to its will that wild Thanksgiving day in 1907, coming away with a 10–0 victory and an immaculate season. Dunlap couldn't have scripted a finer climax to his athletic career.

Almost six years after that game, on June 13, 1913, he made a bride of the former Ada Acheson, a twenty-two-year-old Oregon-born beauty who had toured Illinois and Ohio before coming home in her teens. They settled on the family land and harvested it together.

And now he'd embarked on another career, surrendering his anonymity for a greater purpose. "The position…was accepted…only after prayerful consideration," I.E. Hamilton and D.O. Woodworth later surmised, "because he felt that God was calling him to serve with a higher degree of efficiency than was possible through his life as a private citizen."[329]

Skeptics expressed qualms, but the *Democrat* assured readers that the court's rationale was sound:

> *The county selected the new sheriff upon its own recommendations. Inasmuch as several factions had presented the names of favorites, it was deemed wise to select a neutral who represents no faction and yet who may prove satisfactory to all.*[330]

In other words, the county was gambling with its reputation and, if it wasn't careful, an inexperienced man's life.

THE FATE OF
RUSSELL HECKER

It means $1,200 or $1,400 to you, and he can't do anything with this gun in his face.[331]

April 16, 1922. They were meeting a man Russell Hecker called "Bob." His last name? Russell didn't know, and it wasn't important. Bob had liquor. Frank Bowker had cash.

But he also had a very big mouth.

Hecker sensed his companion was trouble. The whole operation stank. He'd called Frank the night before with a friendly proposition: lakes of bonded whiskey, $85 a case. Tempting, but Frank was busy. So Hecker waited and rang on Sunday morning. Same offer. Frank bit this time, arranging for fifteen to twenty cases of Johnnie Walker Black Label. Then he borrowed $300 from his brother and $685 from his housekeeper, Katherine Cox, to cushion the kitty, hiding it in various articles of clothing.[332]

They met that evening at the Oregon Hotel, within walking distance of Hecker's Portland apartment. Bert tagged along to make sure this partnership was legit and, yeah, probably as intimidation. The brothers put on a show. "Have you got the gats, Bert?" Frank asked as they prepared to make the trip. Bert sure did, presenting a pair of overalls, which Frank unfurled, catching a concealed .38 and setting it on the floor between the front seat and dashboard of Hecker's borrowed car. Bert volunteered himself as extra insurance, but Hecker made it clear that his contact was expecting a duo. They'd all meet in an hour at Eighty-second and Division.[333]

Frank proved unbearable during the drive. Real tough guy, waving that gun around. Expert shot, too, supposedly. Oh, the stories. The horrors he'd run on scam-happy fools. Slick operators who posed as cops. No man alive could out-slick Frank. He'd put an end to that right quick. It was safer to stay on his good side.

Frank had never met this Bob fellow, but he sounded like a pushover. Maybe no money had to change hands. Maybe they could swipe fifteen to twenty cases, make a little profit themselves. But Hecker wouldn't have it. A deal's a deal. "It means $1,200 or $1,400 to you," Bowker argued, "and he can't do anything with this gun in his face." Out came the .38, again.[334]

At last, they neared the meeting spot, where Hecker signaled Bob by turning the car's spotlight away. Misinterpreting the gesture, Bowker went berserk. He should have known. Hadn't this dumb kid been listening? "Hecker, what are you doing?" he barked. "Trying to double-cross me?"

"No," Hecker said.

Enraged, the behemoth cursed and produced his pistol, this time intending to use it. "I'll kill you!" he yelled and fired, the bullet whistling past Hecker's arm and into oblivion. Hecker shoved him backward, reached for his own weapon—the .45 he'd borrowed from Paul Noble just in case—jammed it against Bowker's head and shut that stupid mouth.[335]

"I don't know quite what happened," Hecker told the Oregon City jury more than two months later. "I was afraid. I had to put the body some place. I couldn't keep it there. I drove through Oregon City as fast as I could. Going down the bridge by the Willamette, the water gave me an idea. I guess I was grasping for anything of an idea then."[336]

He rifled through the dead man's pockets, relieving him of identification. That was good, but he needed to do something about Bowker himself because, for one, Russell would likely have to make stops along the way, fill the tank, wash his hands, scrub himself into some semblance of a human being; and two, Bowker was bleeding all over the car, which meant a vigorous cleaning and at least a replaced seat cushion before the vehicle could be returned. Luckily, Hecker had brought a hop sack for the liquor. Now it would serve another purpose. Somehow he managed to squeeze his victim inside.

"I thought I would go home to Albany," he continued,

so I went up. I needed some gasoline, and I thought I could get it some place where they wouldn't know me. I saw a filling station at what they call Horseshoe Park. I drove in and got the gas and tried to act natural so they wouldn't suspicion me. The man didn't say anything...he just looked hard at me.

I got to Albany and went through the town. I thought of a place where I used to go swimming and drove across the bridge of the Willamette. But I couldn't get down there. I drove out onto a dock back in town, but it was torn up. I had to go some place and started through the town. Then I thought of the Calapooia and I went there. Somehow I got the sack out of the car. I tried to roll it under the rail, but it wouldn't go, so I stepped over the rail and pulled it over the side of the bridge.[337]

The courtroom sat spellbound. Many had read of the defendant's crime but couldn't quite connect it to this well-spoken boy. Even his detractors had to admit that Hecker, in his fashionable habiliments and rakish coif, projected an easy charisma. Women thought him good looking, men found him earnest and nonthreatening. Imagine this kid against a snarling, hateful monster. He was lucky to be alive.

Unmoved, special prosecutor Frank Lonergan dissembled Hecker's pabulum, battering the young man with his own, less sympathetic version of events. Excise the gun-waving, the braggadocio and this "Bob"—if "Bob" ever existed—and you were left with an opportunistic weasel. The only truth to this howler was that Bowker was the larger man physically, Hecker would be right to fear him, had he posed an actual threat.

"Isn't it a fact," Lonergan posited, "that when you reached that point on the road, you asked Bowker to look out of the car and see if your friend were coming, then you shot him in the back of the head?"

Hecker fired back an emphatic "No."[338]

The defendant told a good story, but the evidence cast shadows against him. So much of it felt premeditated. Going through Bower's pockets. The witnesses near the Clackamas rifle range who heard only one shot, not two. The missing bullet from the alleged first shot. Driving to a far-off county to dispose of the body. The convenience of a hop sack. Hecker's refusal to allow Frank's brother to tag along. And who or where or what is "Bob"? For a man so frantic, Russell Hecker covered his bases.

The jury thought so, too, and on Saturday, July 1, it returned a guilty verdict after barely an hour's deliberation. Murder in the first degree. Hecker, who stood to meet his fate, quickly buckled back into his chair. Sequestered downstairs, his mother became hysterical and had to be returned to her hotel. Nellie Lainhart, cast by the press as the notorious "sweetheart," wailed in anguish. Barney, poor Barney, rested a hand on his firstborn's shoulder either in comfort or knowledge. A man who himself was familiar with the view from a defense table must have known

the system's flexibility. But for the moment, everyone suspected Russell Hecker would die.[339]

And that was exactly the sentence delivered on July 5 by Judge James U. Campbell, who skipped any sense of prelude before asking the defendant to rise. Had he anything to say? "Nothing at all, Your Honor," Hecker replied. And then came those chilling words—death by hanging—chased by the following advice: "My only recommendation to you at this time is that you devote the balance of your time—of your life—to making your peace with God."[340]

Hecker received little more than two months to prepare. Justice moved swiftly. He would be delivered to "Murderers Row" at the state penitentiary in Salem and then called to atone on September 22.[341]

Editorialists used the occasion to moralize on the Hecker type: "dapper young materialists," claimed the *Morning Oregonian*, "who hold in scorn every convention and who live, as the saying has it, by their wits."[342]

Hecker certainly cut a dashing figure when he arrived at the pen that evening in a proper gray suit, Oxford shoes and straw boater. Were it not for his shackles, he may have been strolling to a ballgame. Even in such straits he seemed genial, declining to speak to reporters but assuring all of his intent to be a model prisoner.[343] His demeanor remained unchanged in drab prison-issue, which, as the *Oregon City Enterprise* observed, "requires neither dressy cravat nor other than a coarse texture of socks."[344]

The end came as clockwork. On the morning of September 22, Hecker went to his reckoning. "The execution of Russell Hecker for the murder last April 16 of Frank Bowker took place here," ran the cold narrative. It was a quiet ending, an anticlimactic demise. But that's what Good-Time Charlies needed: a sobering reminder of wasted life.[345]

Except it didn't happen.

The papers were premature.

Russell Hecker didn't die that day.

Another date was set, nearly two years later.

He didn't die that day, either.

In fact, he wouldn't even die in prison.

There's something to be said for living by your wits. And, of course, tenacious counsel.

MAY 20, 1923
(AND ALL THAT FOLLOWED)

I regret that the sheriff failed to search me and take my gun away, for by his negligence he placed me on the scaffold and himself in the grave.[346]

J. Ellsworth Lillard couldn't believe it. Not even a year earlier, he had been galumphing through mud, looking to bring a sheriff's killer to justice. Now he was walking down Willetta Street, a borrowed Savage in his grip—his own ammunition spent—and having one hell of a Sunday afternoon.

It had begun a couple of hours earlier and twenty-seven miles south, in Harrisburg, when a group of children spotted two men scampering into the Methodist church parking lot and peering into vehicles until discovering Nathan M. Cook's 1919 Maxwell[347] with its key in place. They jumped inside and tore right off.[348] The same car was later reported speeding recklessly toward Albany.[349]

Sheriff Bill Dunlap, who'd finished Kendall's term and was elected later in '22 to one of his own,[350] got the call just as motorcycle officer Lillard returned to the jailhouse with an ornery drunk in tow. The sheriff collected his car from the nearby Murphy's Garage, enlisted Lillard and, for some reason, brought along his wife and their houseguest, Albany College student Geraldine Hamilton.[351]

This procession bounded south down Pacific, deep toward the flat country. Lillard encountered the suspicious missile just beyond the McFarland schoolhouse in Tangent and whipped around to see the sheriff switch lanes and force his quarry to stop. Dunlap stepped out as Lillard moved in on foot

from behind. The deputy reached the driver's side first and began asking questions, to which he received no response—not even resistance.

"We know where you got the car," he said.

"You are under arrest," Dunlap added.[352]

The lawmen discussed how to best get their collar to town. The sheriff didn't want them in his car with the two women, and they certainly weren't going to be traveling in a motorcycle sidecar. So he decided he'd direct his prisoners from the backseat of the stolen vehicle, with Lillard trailing close behind and his wife and Geraldine bringing up the rear. He ordered one of the suspects, Arthur Beckley, to take the wheel while the other, George Parker, sat shotgun.[353]

The drive went as planned for a while. Dunlap kept watch, ready for trouble, but his pilots seemed unfazed. That all changed as they passed just south of the fairgrounds and approached the city, at which point Beckley inexplicably leaned toward Parker. "You fellows better not start anything," Dunlap warned. Then suddenly, for the first time since the trip began, Parker and Dunlap were face-to-face, and Dunlap realized that in their zeal to make an arrest, neither he nor Lillard had searched their prisoners for weapons. He was staring at the wrong end of one now. Panicking, the sheriff grabbed the left-hand side door but didn't escape in time. Parker squeezed the trigger, driving a single shot into Dunlap's ribs[354] as he threw the door open and flung himself out.[355]

Lillard, helplessly, watched the scene unfold. First he heard a shot. Then he saw his comrade launch head-first to the street and crumble into a heap on his back. When Lillard stopped his motorcycle, Dunlap, running on pure adrenaline, leapt to his feet and poured himself into the sidecar, over the concerns of his now-hysterical bride.[356] "How bad are you hit?" Lillard asked. The sheriff shrugged it off.[357] And what once had been a small parade became a high-speed shootout through the streets of Albany.

The combatants reunited about sixty feet apart at Eleventh Street. Lillard produced his fully loaded .30 Luger, and the officers began blasting in tandem.[358] At Ninth, Beckley swerved left onto Elm,[359] pistol in his right hand, returning fire.[360] A stray retort lamed his steering hand, and he soon lost control, plowing into a wood stack and skidding to a stop on the sidewalk.[361] The suspects took off, vaulting over an alley fence between Ninth and Tenth.[362] The officers gave chase, although Dunlap fell behind, firing his weapon as he tumbled to the ground. He steadied himself slowly, blood from his wound spreading like wildfire beneath his shirt, and staggered back toward Ninth and Elm, where his wife retrieved him and drove him to the St. Mary's Hospital.[363]

George Parker and Rulie Johnson came down this alleyway between Ninth and Tenth Streets in 1923. *Author photo, 2015.*

Parker and Johnson hid in this neighborhood, at Ninth and Willetta Streets. Johnson was found under the house in the foreground at left. *Author photo, 2015.*

Lillard emptied his gun in the fray—all nine shells in the chambers plus the three in his pocket.[364] Once clear of the alley, Beckley went right; Lillard concentrated on his cohort as he sprinted onto Willetta and disappeared. The deputy went back around the block and encountered Mrs. F.O. Anderson, who lived in the neighborhood and had spotted Parker ducking

into an outhouse on the James Salvage property, at the corner of Willetta and Tenth.[365]

Residents by now were leaving their homes, drawn by the sounds and shouts and sights of multiple armed cops now roaming the streets. One neighbor got the deputy's attention and told him Del Brown had a rifle he could use.[366] Lillard paid Brown a visit, procured the cannon in question and strode down Willetta toward the Salvage lavatory.

He pounded on the door and demanded Parker's surrender. Every second of nothing infuriated him further. When his third such request went unanswered, he stepped back, lifted the rifle, pointed its barrel low and stripped that silence of its lie.[367] The resulting report was followed by an even louder, howled détente from within. Parker emerged, hands high, limping from a wet new hole in his leg.[368]

Shortly after Gilmore was removed, Mrs. Orrin Ireland led officers to Arthur Beckley. She had discovered him during a break in her captivation with the scene. She happened to look down and see a strange knife gleaming on her lawn, then carefully toured her property until she noticed a human figure hiding within a wall of her house near the corner of Ninth and Willetta.[369] Trapped, weary and wounded in her left wrist and shoulder,[370] Beckley gave up without a fight.

Hours later, the prisoners found themselves at the same hospital with Dunlap, although his injury was significantly more grave. They rested and recovered, feeding aliases and false histories to officers and reporters. In truth, Arthur Beckley was twenty-five-year-old[371] Charles Rulie Johnson[372] of Centralia, Washington, with a largely small-time criminal history dating back to his youth. Most recently, he was an escapee from the Colorado state prison east of Cañon City,[373] where he'd been serving one to seven years for forgery.[374] (In fact, he broke out the very day Kendall and Healy were murdered in Plainview.)[375] George Parker also went by George Gilmore, but he was really George Parker, thirty-four,[376] of Evansville, Indiana,[377] or so he said,

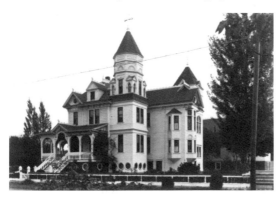

An undated photo of St. Mary's Hospital in Albany. *University of Southern California Libraries and California Historical Society.*

and as far as his back story went, he bragged, "You won't get much from my fingerprints."[378] The most authorities would unearth was a stint in Sacramento as Gilmore for horse theft.[379]

According to Johnson, the two met in Kelso, Washington, earlier that month; Rulie'd been on the run since splitting Colorado the previous June. They'd gone south, alternately walking and hitchhiking, and ended up a few miles outside Springfield, Oregon, then turned back, landed in Harrisburg and found a car just itching for a boost.[380] Linn district attorney L. Guy Lewelling suspected they got sidetracked at least twice, first to rob a Cottage Grove man of $3 worth of silver[381] and then to relieve a Wilsonville bank of $13,000[382] (the *Albany Evening Herald* claimed $19,000).[383] Despite the bank president's denial,[384] these accusations weren't entirely balderdash: among the men's effects were three guns,[385] a coin wrapper[386] and about $3 in silver.[387] Both were carrying more than $40 apiece, and one wore a vest with $200 sewn in.[388] Neither suspicion yielded much. Most would consider this the apex of their criminality and all they'd be remembered for.

Dunlap was conscious most of the evening, receiving relatives and detailing the incident for Judge Victor Olliver. He identified Parker as his assailant, "the man who was not driving and who had a sharp face."[389] Doctors tended to the sheriff, placing him on the operating table at 8:30 p.m.[390] They extracted the bullet, which had penetrated between the seventh and eighth rib, torn the right kidney, passed under the liver and through the diaphragm to wedge firmly into back muscle.[391]

Family and friends clung to hope. To get shot point-blank, continue like he did and to hold on so long—boy was a tough old bird. But Dunlap knew otherwise. He just knew. According to his wife, as she loaded his hobbling form into the car on Sunday afternoon, he said, "Take me to the hospital, as I am going fast." In a candid moment at bedside, he told her he wouldn't make it.[392] He'd lost so much blood. He was in such pain. They talked of wills, said goodbyes. And at 1:20 p.m. on Monday, May 21, 1923, more than twenty-four hours after Parker's bullet entered his body, William Dunlap— football hero, farmer, lawman—left it behind.

By then, Johnson had been cleared for release and taken to the Linn County jail. Parker briefly remained in bed, his status upgraded to killer (first-degree murder),[393] before leaving for prison that evening.[394] Lewelling wanted to sic a grand jury on them, send them to Salem and snap their necks as soon as possible. The trick, of course, was to keep them alive long enough to die legally. A lot of hot-blooded lynching talk floated through the county, folks still stuck in the nineteenth century. There were reports of

Shedd farmers looking to join posses. OAC students in Corvallis allegedly threatened a demonstration. Security was tight during the Parker transfer; he was flanked by four officers, including Lillard and deputy sheriff J.F. Roy, one of Dunlap's best friends. National guardsmen patrolled the streets until 11:00 p.m., and special deputies remained on high alert. But the evening passed without incident.[395]

Despite Lillard's bravery, deputy Frank Richard, a contender for the main office after Kendall's death, was named Linn's new sheriff on Tuesday, May 22. The appointment came fast and easy. The county didn't mess around. No lobbying. No dark-horse candidates, either. Richard was a veteran officer, fifty-five years old, with twenty-five years of experience in both Albany and Lebanon[396] (He also left the post alive in 1929, thus ending the curse;[397] "several weeks' illness" claimed him in 1949).[398]

The grand jury convened on May 29 and within two days had indicted both Johnson and Parker. On the morning of June 25, both men, handcuffed together in criminal matrimony and supported by defense attorney Guy L. Thacker of Chehalis, stood before Judge Percy Kelly and pleaded not guilty to murder and car theft. Naturally, the courthouse was packed, as if illustrating Thacker's request for a venue change—his clients weren't getting a fair trial here.[399] Parker and Johnson didn't think so, either, and aimed to do something about it.

Sheriff Richard was strolling across the courthouse lawn to the jail on July 1 when he spied something funny—well, maybe not funny, but peculiar and not at all right. He saw a man in what should have been an empty enclosed yard. Even worse, that man was George Parker. Richard's gait became a dead sprint. Parker, startled, ducked behind a tree, an exercise in futility.[400] He would later claim to have been within reach of a stone but declined to use it as a weapon. "I liked Richard," he explained.[401]

His escape had been made possible through a series of iron bars extending over the cells. All it took was a two-by-four to bend one back just enough for a lithe figure or two to squirm past to the top of the cage. From there, it was a tedious knife (where that came from was anyone's guess)[402] and hammer dig past four layers of brick in the jail's west wall, with a blanket spread across the latticed ceiling over the corridor. A broom handle pulled the bricks from the mortar. The blanket muffled them, kept them from crashing to the floor or raining conspicuous dust. The prisoners sang to cover their labor. Eventually, voila: an opening measuring fourteen inches wide and ten inches high, with about a ten-foot drop to solid lawn.[403]

Back in custody, Parker muttered, "Tough luck"[404] as confinement reembraced him and workers sealed his handiwork.

Not everyone was accounted for, of course.

Relaxing at Takenah Park, bystanders noticed someone bounding east from the jail shortly before Richard's discovery. A similar figure was also spotted near the cemetery, maybe hijacking a bottle of milk from a nearby truck before going on his way. Another witness claimed that around midnight, he'd been forced by a man to drive into Corvallis and drop him off near the Oak Creek Bridge. Benton County sheriff S.N. Warfield planted guards at the bridge going into Corvallis. Lillard went to Eugene to pursue a potential lead involving reports of a mysterious head peeking out from a field, only to duck back down at the sign of coming traffic.

But despite continued sightings of a five-foot-nine enigma[405]—and the appearance the following March of an angry wife in Kelso who had married him under yet another alias (Livingstone)[406] and was desperate to shed him from memory[407]—Rulie Johnson had taken a permanent powder. A $500 reward for his recapture[408] went uncollected. (Parker would say their plan was to hide in nearby trees until nightfall, and he believed Johnson did just that while a dragnet scrubbed the city.)[409] People may have seen him, but no one with a badge has ever found him.

George Parker was on his own.

He and Thacker prepared a self-defense strategy. Their version of events largely matched the official record until a very critical juncture: what took place inside the Maxwell. Here, Parker made innocent conversation with the sheriff, inquiring about the county's penalty for car thieves. In an overly sour mood, Dunlap growled, "That depends on how much we get on you" and then followed with an unkind reference to Parker's mother. Parker took offense and said so, resulting in an unprovoked gun blast through his cap. Only then, he said, did he fire. He produced the cap as evidence, and indeed it bore a hole, but no one agreed on its cause.[410]

Much to the city's chagrin, Parker's trial was delayed to July 18 for a laborious jury selection.[411] Once that was in place, however, justice moved swiftly—alarmingly so. It heard testimony from Ellsworth Lillard, Geraldine Hamilton, Nathan Cook, Justice Victor Olliver, Frank Richard and Ada Dunlap. It listened to L. Guy Lewelling dismantle the defendant's account, claiming Sheriff Dunlap couldn't have fired into Parker's cap because "the hole was larger at the place where the bullet entered than it was where it came out."[412] Thacker challenged this point, holding the item and demonstrating how a bullet fired from the backseat could make

exactly that perforation. He also claimed that the sheriff was stooped over Parker when the fatal shot erupted.[413]

"The eyes of the state and county are upon you," Lewelling told the jury in his closing statement. "I want you to cast aside your prejudices and your sympathies, and to render your verdict according to your deepest convictions."[414] It was a nice but unnecessary bit of imploration. Lewelling could have recited the Magna Carta in its original tongue, and Thacker could have been the most dazzling attorney to ever ace the bar. The jury could have been the most pitying ever assembled, but it didn't matter. The county had withstood enough violence for two years. After killing Charles Kendall, Dave West punched his own clock. After Dunlap's death, Rulie Johnson escaped. Yet George Parker, the man who pulled the trigger, stood before them, living, breathing and wholly at their mercy. Justice had handed these twelve people—ten men, two women[415]—the power to exact revenge at last.

The jury began deliberating at 2:15 p.m. on Thursday, July 19, and returned one hour and eleven minutes later with the verdict. Foreman J.C. Porter delivered it to the county clerk, R.M. Russell, who then read it aloud to the crowded room: "We, the jury, find the defendant guilty of murder in the first degree in accord with the indictment."[416] The jury offered no sentencing recommendations, which meant it rather enjoyed the prospect of hanging George Parker.[417] So did Judge Kelly, who set execution for July 31 and sent Parker immediately to the state penitentiary.[418]

The usual rounds of appeals and reprieves followed. Dates were moved: July 31 to August 31. Parker came close to dying that day, waiting in his death cell with the gallows ready to go as his attorney raced the appropriate papers to the executive office.[419] The prisoner lingered long enough to reflect for the very journalists he loathed, the bums who took his picture in the hospital and slandered his name. They didn't get it. He was only protecting himself. But the damn crooked town was out for his blood. He knew the truth and, now, so did the Lord, for he had converted to the Catholic faith. "I regret," he said, "that the sheriff failed to search me and take my gun away, for by his negligence he placed me on the scaffold and himself in the grave."[420] As for his vanished companion, Parker harbored no resentment. "Rulie Johnson had nothing to do with it," he said. "Johnson is guilty of auto theft, but he is not guilty of an attempt upon the sheriff."[421]

That December, the state Supreme Court refused Parker's appeal. "George Parker Must Hang," the headlines brayed for months. Now the highest mortal authority was demanding it, too.[422] He'd see the new year, but his subsequent days were short.

They came for him at 8:30 a.m. on Friday, January 4, 1924. He was accompanied to the death cell by his constant companion, Father J.R. Keenen. There he spoke his final words, addressing those who'd driven to Salem to watch him die.

"I was a poor, unfortunate boy who came to your little town," he said. "I have no vengeance in my heart for any of you. I never said I should be turned loose, but don't think the trial was fair. Gentlemen, if any of you feel unkindly to me, I forgive you. There is but one man here who has stood by me through it all, and that is Father Keenen. Now I am ready to go."[423]

With that, he turned to his captors.

"Let's go," he said.

And so he went.[424]

Russell Hecker's Luck Holds Out

When there is a matter of doubt and a man's life is in the balance, then it is your duty to see that such a man gets every consideration in his fight to escape death.[425]

As Judge Campbell thundered on the Almighty's behalf in July 1922, Russell Hecker's defense team stockpiled ammunition for appeal, which it filed barely twenty-four hours before deadline.[426] One of its most peculiar charges concerned five female jurors who briefly left deliberations for another room, unchaperoned by the bailiff, thus violating protocol. Campbell himself didn't escape scrutiny, either, dizzyingly accused of "refusing to allow the motion for dismissal after the completion of the state's case in chief, erred in the admission of certain evidence objected to and further committed an error in refusing to give certain instructions to the jury requested by the defense."[427]

Campbell heard the appeal on Monday, July 31. He denied it—no surprise. Their claims were ridiculous. The wandering jurors chatted only among themselves and were carefully observed. A second strike for Hecker, but he wasn't out yet, as his champions, led by Gilbert L. Hedges, vowed to circumvent Campbell for a less biased audience in the state Supreme Court.[428]

As the wheels of justice turned, Hecker moved from Salem to the prison in Multnomah County, where he'd be closer to family and to Nellie Lainhart, with her daily gifts of snacks and fantasies.

The state was in no hurry to kill him. That fall, on the day he was initially scheduled to be executed, Hecker presided over a kangaroo court, trying

members of Beaverton's Premium Pictures[429] for minor offenses during location shooting for *The Cleanup*, a silent crime melodrama starring George Larkin and Ruth Stonehouse.[430] (It was released in 1923 as *The Way of the Transgressor*.)[431]

He lived to see Ben Olcott ousted that November from the governorship for the more Klan-friendly Walter M. Pierce. (Pierce endorsed the group's troublesome Compulsory School Act, which abolished private [read: targeted] Catholic schools.) He lived to see the New Year, Thanksgiving and Christmas 1923—though the latter wasn't merry. One week earlier, his attorneys had met resistance from the high court, which refused a new trial.[432] Hecker would meet the hangman, after all, at 10:00 a.m. on May 21, 1924. Back he went to Salem.[433]

But the public had begun to soften. It's not hard to see why: Hecker was a handsome cuss, sympathetic, sensitive. He also had the fortune of being alive, a privilege denied his victim. Russell shaped the narrative, dragging Frank Bowker—musician, bootlegger, ex-husband, father to twin girls—through whatever muck he fancied. A movement was afoot to spare his life, one that would plant him before a force more powerful than any judge.

It was kismet, really, that *Woman's Home Companion* reporter/editor Frederick L. Collins would be working that year on a sixteen-part series profiling America's governors. It was positively serendipitous that on the morning of Monday, May 19, he happened to be on a train from Portland to Salem, meeting the *Portland News'* front-page gaze. "But 44 Hours to Live"—who could resist such a headline? Especially since its content, presented as a "letter," was directed to the man he was en route to profile:

> *To Governor Walter M. Pierce at Salem—*
> *Dear Governor:*
> *A copy of this paper with this article marked in blue pencil is being mailed to you by special delivery. By the time you get this issue, Russell Hecker, seated in a death cell only a few blocks away from your armchair at the capitol, will be counting but 44 hours for himself to live. He has been sentenced to die on the gallows at ten o'clock Wednesday for the murder of a bootlegger, Frank Bowker. Since Hecker's conviction, new facts have been unearthed which hundreds of Oregonians believe should warrant him a new chance. Those have been placed upon your desk for your perusal.*
>
> *Governor, a life rests upon your judgment. You need not free Hecker. But you can give him another chance by delaying the hanging or commuting him to life imprisonment. The people of Oregon are not thirsty for this man's blood. When there is a matter of doubt and a man's life is in the balance,*

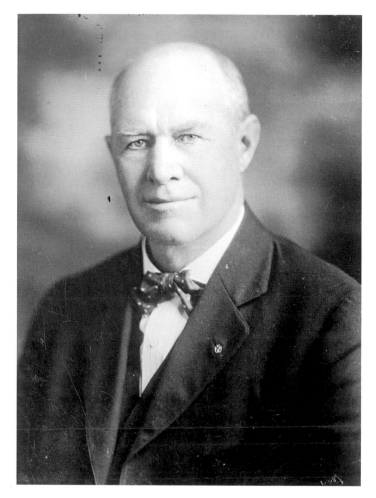

Oregon governor Walter M. Pierce. *Bain News Service, Library of Congress.*

then it is your duty to see that such a man gets every consideration in his fight to escape death. Don't let Hecker die on the gallows until the state has proven absolutely that he is guilty of a brutal, premeditated murder. Hecker deserves another trial.

Yours truly,
The Portland News *and Hundreds of Oregon Citizens*[434]

Consequently, when Collins arrived in Salem, he found his subject preoccupied. "A man's life is in my hands,"[435] Pierce said by way of greeting. Splayed across his desk was the promised copy of the *Portland*

News, plus a map of the alleged murder scene, concocted anonymously and apparently convincing in its argument that Bowker could not have been killed in that spot. Another man loomed over the documents, studying them with obsessive curiosity. Barney Hecker, in the flesh. He was flanked by counsel and a solemn if emotional young woman desperate to liberate her one true love. Soon, they all sat to dissect the Frank Bowker case to its finest, most trivial points—often with Pierce as the prisoner's fiercest advocate.

"Did Russell know how much gas was in the tank when he started out that night?" he asked.[436] Of course, no one had any idea.

"Yes, he did," Pierce fired back, "because he said so when he took the car out of the garage. And that is one of the factors in his favor. He had enough gas to go on the errand on which he and Bowker started. He didn't have enough to travel a hundred miles to hide a body, or to make his own escape."[437] (Left unasked was how, with $1,400 suddenly in his pocket, gas was even a concern for Russell Hecker.)

Pierce eventually agreed that the prisoner acted in self-defense. But, he concluded, murder was murder, and for that, Hecker could not be pardoned. Instead, his death sentence was commuted to life.

"I cannot believe that a young man, twenty-four years old, would premeditate murder as carelessly and with as little forethought as the prosecution claims Russell Hecker planned the killing of Frank Bowker," he said in a statement.[438]

> *During the evening of the day on which the tragedy occurred, Russell Hecker was frequently seen by his associates in a normal condition. He borrowed a gun from a friend, took it to the Imperial Hotel and left it with a bell boy, asked for the revolver, and put it in his pocket: thus leaving a perfect trail, easily followed, of his handling of the fatal weapon that caused him the trouble. If he had deliberately planned the murder, he surely would not have been so careless in his movements.*[439]

Russell Hecker got his extension, and Frederick L. Collins left with a tidy conclusion for his piece. He wrote of awakening the next morning to less dire headlines: "Hecker's Life Spared," crediting this turn of fortunes to the "brave little man" who squired the scribe through the melodrama of a life in balance, showed him the very penitentiary in which Hecker was incarcerated (they apparently did not meet him) and whisked him through the insane asylum where one Carson Beebe was paying for his fabulism.

"God knows how many there'd be if we had 'em all," Pierce sighed. "Even now, it takes a sack of flour every day just to make their gravy."[440]

Collins returned to New York and packed these experiences into his own gravy. The resulting story, "Yes, This Is Walter," appeared in the November 1924 issue of *Woman's Home Companion*, paired with a less ripping exposé on Connecticut's Charley Templeton.

Fifteen years after the state demanded his death, Russell Hecker was a free man, his life sentence clipped to twenty years.[441] Nearing forty, he was starting over. His once-devoted Nellie Lainhart, who'd lobbied so hard for his release, was gone. She'd married Portland attorney Joseph N. Helgerson in 1932,[442] but that ended quickly. Now Nell was in either Boise, Idaho, or San Francisco, California, sixteen years before her next and final marriage. Hecker's parents remained accommodating, but they were getting older. In fact, the whole family occupied a Portland house, with Russell supporting himself in such vocations as waiter and salesman.[443] It was while visiting Spokane, Washington, in the latter capacity that he infamously made the papers again.

It was an accident this time, a tragic mistake. Rains pummeled the city on Friday night, July 26, 1940, burying crosswalks, swallowing basements, falling, in the words of the (Spokane) *Spokesman-Review*, "faster than sewers could drain the water away."[444] Hardly ideal driving conditions, but Russell was out there, coming down Augusta Avenue with two women in his car. The side street T-boned into the larger Washington Street, and by the time he spotted the Diamond cab, it was too late. Both vehicles shrieked, desperate to avoid the inevitable, but they collided, clearing Washington's curb and slamming into the protective fence surrounding North Central High School's playing field. Taxi passenger John Lundeen was seriously injured and rushed to the hospital, as were Hecker's companions, Barbara Marito and June Poerch. The former was treated for cuts and bruises; the latter hurt her back. Hecker suffered a broken rib or two. Cab driver Larry Skiles, however, sailed from his vehicle and hit the pavement, dead.[445] The next day, Hecker was charged with negligent homicide and released on $500 bond, although no one seems to have pursued the case.[446] Two years later, Hecker sued the cab company for damages[447] and won—not every dime, but a decent sum.[448]

These wisps of paragraphs mark Hecker's last dalliance with notoriety. Otherwise, his name surfaces only in mundane documentation. One would hope he fell into anonymity. Maybe he'd started a family. Maybe he'd recovered, cleansed the sins of youth. Of course, with the dearth of Hecker

news after the early 1940s—not a drop for the rest of the century—it's also fun to imagine a crafty centenarian dodging death, throwing money and lawyers at every attempt.

But none of these things happened. At least, I don't think they did. Russell disappeared with a magician's flair. If he lived, he kept a low profile. If he died, no one bothered to note it. The only clue to his fate amounts to nothing more romantic than a potential clerical error. A "Russell B. Hacker" died in Portland in 1944.[449] No one by that name lived in the city at the time. So perhaps it's fitting that Russell Hecker went like a lonely car on a dark, empty road. That mortality would find him and take its revenge, offering a final punchline: the dapper young man at an entire state's attention two decades earlier had passed, forgotten and misidentified.

THE RESURRECTION OF
CLOY ALVIN SLOAT

Is that a newspaperman?[450]

While Albany mourned Sheriff Kendall in 1922, the prisoner who'd pleaded so earnestly, so futilely, for understanding from that very lawman—nary a week before his violent demise—was coming to grips with the fact that his own life was over.

Unlike Russell Hecker, Cloy Sloat never stood a chance. He lacked charm, inspired no sympathy. His crimes were so heinous—those poor little girls—that every account of even his appearance sneered with disgust. Salem's *Capital Journal* opened a front-page article with an appraisal of the ex-educator as "[s]uave, bland, almost oily...Like other subjects sometimes mentioned by students of abnormal psychology, he has the appearance of being entirely normal."[451] Sloat, in turn, had no particular affection for the reporters who observed and prodded him, scribbling God knows what into their notepads. While still incarcerated in Albany and conferring with Salem's district attorney through his own attorney, he caught one such vanguard of the press slinking into the room. "Who is that?" he demanded. "Is that a newspaperman?" Out the wretch went.[452]

Sloat was delivered to Salem in chains on June 20, 1922. Two days later—less than twenty-four hours after Sheriff Kendall, the Reverend Healy and Dave West met their tragic destinies—he stood before Judge Percy Kelly at the Marion County Circuit Court and entered a guilty plea to three of the counts against him. Perhaps with Linn County district

attorney L. Guy Lewelling's threats fresh in his mind—that if Salem didn't crucify Sloat, Albany would—Kelly threw the prisoner one life sentence and then a second.[453]

It proved too much for his sainted mother, Sarah. Little more than two years later, she was gone, dead at sixty-four.[454] Deputy warden J.W. Lillie rejected Cloy's request to attend her service. Not even his family, his aunts and uncles, interceded on his behalf.[455] They were finished with him, too.

Sloat's incarceration was uneventful and long. Yet the years passed quickly. The '20s became the '30s. The '30s became the '40s. He was still inside when Russell Hecker walked free, when he slammed his car into a taxi cab one awful night in Spokane and even when he faded out. World War II began and ended. The Atomic Age arrived.

Then, in March 1955, the Oregon Supreme Court argued *Cannon v. Gladden*, filed by state prisoner Frank Cannon, who in 1937 was sentenced to life for statutory rape, thanks to a 1919 law that "fixed the penalty [the original 1864 law limited sentencing to no more than twenty years for either statutory or forcible rape] for assault with intent to commit rape at life imprisonment in the penitentiary or for a period of not more than 20 years."[456] (The named defendant was state prison warden Clarence T. Gladden.) Cannon claimed the sentence was excessive, that he was "convicted of an offense greater than that charged in the indictment."

"It is unthinkable," the decision argued in part, "that in this enlightened age, jurisprudence would countenance a situation where an offender, either on a plea or verdict of guilty to the charge of rape, could be sentenced to the penitentiary for a period of not more than 20 years, whereas if he were found guilty of the lesser offense of assault with intent to commit rape he could spend the rest of his days in the bastile."[457] As a result, the 1919 law was declared unconstitutional.[458]

While the decision affected, of course, Frank Cannon, it also brought relief to others.

Four months later, on July 6, 1955, Cloy Alvin Sloat was paroled. He was sixty-three, breathing freedom for the first time in thirty-three years.[459] He left Salem behind and found living arrangements just south, in Jefferson, within fist-shaking distance of the towns that put him away. Enough time had elapsed that both had largely forgotten his name, until barely fifteen months after his release, he was back in the newspapers again—for a minor infraction—and his past appeared poised to end him for good.

It was stupid. He was drunk. Who doesn't get drunk from time to time? But the Corvallis police arrested him, anyway—not good for a fellow on

parole for crimes that condemned him to an eternity in lockup.[460] Of course, his record came up in the press. But unlike in 1922, when he pleaded guilty before Judge Kelly and surrendered half his life to the state, Sloat decided to fight. He didn't want to go back for any amount of time. He wanted those parole terms gone as well. The Benton County jail was OK for now—he waited for his date with the county's circuit court—but he wasn't planning on a permanent vacation.[461] This judge, Fred McHenry, obliged him. Freed him for real, all debts paid.[462]

The next time anyone heard from Cloy Sloat, he was living in Portland, reinventing himself as, of all things, a novelist. In late 1957, Comet Press Books of New York released his first and only title, *Sunset Valley: A Romance of the Oregon Country*. He dedicated it to his mother, whose funeral he had been forced to miss thirty-three years earlier, and to "all the hardy pioneers who bore the hardships, braved the hostile Indians, and faced the unknown dangers and perils of the overland trails."[463]

Read today, it's Kodachrome prattle, tracking multiple generations of a virtuous pioneer family in a fictional stand-in for the Willamette Valley. Stock characters roam through en route to oblivion, muttering fragrant prose ("Little girl, I want you there next summer to glide over the pulsing, whispering bosom of the great and noble river")[464] in sometimes painfully phonetic dialects. Such panting stereotypes as Old Mose, the faithful slave who shunned emancipation, and various members of the Morgan brood, hateful, imbecilic, half-feral enemies to the central Carters, suffer the worst in that regard.

Sunset Valley ends with the discovery of a buried fortune, the blossoming of true love between young Frank "Curly" Stoddard and the feisty Betty Jean Carter (with a name like that, what choice do you have?) and old Grandmother Carter returning to Sunset Valley after a twenty-year absence to marvel at its majesty. "At the first dip or two," surmised a subsequent *Albany Democrat-Herald* review (absent any mention of Sloat's notoriety—weird, as it's written by Charles Alexander, who surely remembered), "there was a feeling this fellow was going just a bit far…Surely, it's laid on thickly, but Oregonians, at least, will find their eyes smarting at times."[465]

Sloat responded effusively to the lukewarm accolade. "I wish to express my appreciation and gratitude for the manner in which you handled the announcement of my book, *Sunset Valley*," he wrote. "Not only does it show efficiency in newspaper work but it also demonstrates one of the greatest things for which a newspaper should stand, i.e., its use of articles of benefit to all coming in contact with it."[466]

There would be no follow-up novel. No more stories, fictional or ones involving him. No more shouts of "Is that a newspaperman?" Cloy Sloat spent the rest of his life as anonymously as he could. As if attempting to catch up on lost time, he lasted almost twenty-three years past his parole date: April 1978, a free man to the end.

Epilogue

1979–1989

It's been forgiven. You've got to do that to go on.[467]

You always saw him if you passed the house, Lanky old man, handsome, a stoop betraying his five-foot, ten-inch frame. If you stopped to talk, you wouldn't find a friendlier conversationalist, kind and articulate. But a light would dim when you said goodbye.

His neighbors knew his name, but few knew much about it. You had to be a certain age for that to register. He and his wife, Laverne, had moved to Albany about ten years earlier, taking residence downtown, across from a building that once housed the electric train station. Both were active until Verney took sick for the last time, weakened by the cancer that finally claimed her in September '78. Now he was alone in a house that used to belong to his mother and had long belonged to him.

He'd actually come to town years earlier. It was a different place then, so much smaller. The farmhouse he knew as a boy, with its fields and relaxed horizons, had been squeezed into a forced suburbia, historic and modern commingling with streets, thoroughfares, plazas and shopping centers. Development had uprooted the Linn County Fairgrounds, once the fastest mile horse track on the West Coast, from Highway 99E and Queen Avenue and thrown it farther north, closer to Interstate 5. An interstate! Garages, gas stations and industrial plants sprouted from its ruins. And the town continued to grow, swarming ever south, erecting sketches and skeletons of the future.

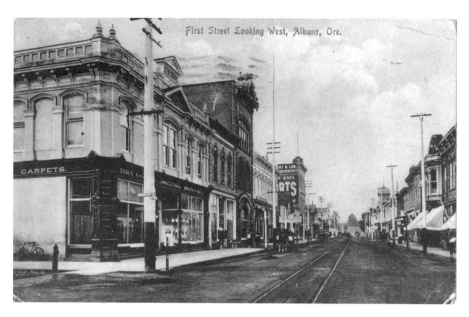

Looking west on First Street, Albany, Oregon, circa 1909. *University of Washington Libraries, Special Collections, UW 36888.*

The same view at First Avenue and Broadalbin Street in 2016. *Author photo, 2016.*

He could stand at Monteith Riverpark and remember when it was no park at all—just soft earth and river beneath a groaning bridge. Its supports still stood, solid against the current, but the bridge itself was dust, crushed

The supports that once held the Albany Steel Bridge. *Author photo, 2016.*

by dynamite in 1926. It was replaced downstream by another—woven for permanence from steel and concrete—that connected Ellsworth Street to the Albany–Corvallis Highway and was now Highway 20. (Another rose in 1973, one block east on Lyon. Its purpose was to relieve its sister of congestion, sending traffic from Albany to Corvallis.) Looking to the sky, he could imagine the speck of an airplane he'd watched buzz over, then land at, Bryant Park in 1910. He could close his eyes and feel the *Pomona* steamboat power past, in concert with logs fed to the Willamette from sawmills long destroyed.[468] Higher up the banks perched First Street, now First Avenue. He could see the parking lot behind the JCPenney that emptied into Broadalbin and crept around the Venetian Theater, the Globe in his day, where he thrilled to films and the occasional stage show, a few of which even featured his father.

His father.

It's hard to imagine how Clark Kendall felt when Dave West killed his father. He spoke little ill of anyone, and the words he chose to leave us are no more revealing than letters or descriptions of nature. He rushed home by train that evening in 1922 and desperately wanted to go to Plainview, distraught by the idea of his father so alone, abandoned beneath the sun. (Years later, he commissioned a saddle as a tribute to the man, deliberately altering his death date to June 22, celebrating his ascent to the angels and not the tragedy that ended his life.)[469]

Estella Kendall moved into this Fifth Street residence in July 1922 and remained there for the rest of her life. *Courtesy of Judy and Terry Broughton.*

Clark's mother drew the line after that day. No more guns in the house. She forbade her son from pursuing a profession that required one. You can represent the law, she said, but enforce it through words. Clark, it was decided, would become an attorney.

Charles left them very little when he died. There was no will. Money became an issue. Clark's schooling. Basic necessities. While Albany felt sympathy for the Kendalls' plight, his family couldn't live in the sheriff's quarters forever. Emergency wheels began to turn, but the wait was interminable (it would take until February 1923 for the state to enact a resolution promising $3,000 to the widow Kendall as proper recompense).[470] One month after her husband's death, Estella moved into a two-story house, courtesy of H.F. and Elizabeth Merrill, in league with three Althouse sisters, Mary, Annie and S. Katherine.[471] It stood about three blocks east of the Linn County jail, and Estella remained there the rest of her days.

She would always grieve Charles but never played the professional widow. Even when her husband was alive, Estella was indomitable. She indulged a penchant for writing, contributing gardening columns to the *Albany Democrat* and scratching her own verse into scraps of paper. The tragedy didn't define her; she would not allow it. She became, of all things, an Avon lady—a successful one, too—and somehow supported herself while maintaining a large house. She even supervised extensive kitchen renovations and cultivated the finest garden in town.

Estella experienced much in the time she had left. She saw mankind venture into space. The inauguration of John F. Kennedy. The powder keg tensions of integration. She was around for Martin Luther King Jr.'s "I Have a Dream." The birth of zip codes and seven-digit phone numbers. Beatlemania thrilled Great Britain, and a Woody Guthrie acolyte struck pay dirt with *The Freewheelin' Bob Dylan*—not that she would have noticed.

She died on October 1, 1963, at the age of ninety,[472] outliving her martyred husband by forty-one years. A brief notice in the October 3 *Albany Democrat-Herald*[473] was followed four days later by a full-blown tribute from editor

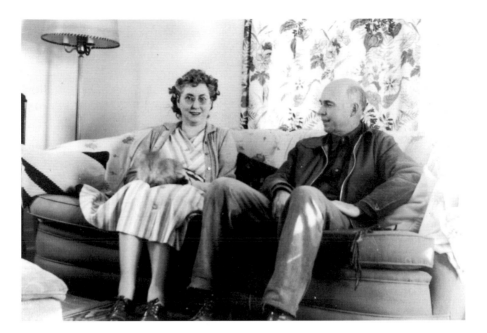

Laverne and Clark Kendall at home in Klamath Falls, March 1949. *Courtesy of Judy and Terry Broughton.*

Wallace Eakin, who recalled in detail that awful afternoon in 1922. "Death of Mrs. Estella Kendall last week," he wrote, "revived in the memories of old-time residents of Linn County a tragedy which to this day stands as the most sorrowful of its kind ever enacted here."[474] Estella was buried next to Charles, and there they remain, inseparable.

Clark and Laverne Kendall were then still residing in Klamath Falls. They'd had a ranch there for years, ever since Clark abandoned his career in law. After graduating from Albany College, then Oregon Agricultural College, and passing the Oregon Bar Exam in 1929, he'd gone to Hill, Marks & McMahan, expanded from its days defending Carson "Pete" Beebe. There he met Laverne, who was working as a legal secretary.[475] He was a decent lawyer, but he lacked the stomach for its more loathsome qualities—the calculated indifference to suffering, the cutthroat politicking, the willingness to twist interpretations of law to win. The couple, who'd married in 1931,[476] left Albany for the more pastoral sprawl of Klamath Falls in 1945.[477] After Estella's death, they rented her house out until moving in themselves in 1970.[478]

Eight years later, it was just him.

But happily, not for long.

Terry Broughton met him first. He was a young jar collector. And downtown Albany, with its historic homes, older residents and derelict buildings, made a thriving market for such an enterprise. Someone always had something neglected on a shelf or lost in a basement. Terry would take what most people considered clutter, clean it up, repair it if it wasn't too far gone, revitalize it again.

In a way, he'd do the same for Clark Kendall. Clark's wife was gone, and they'd had no children, so the Kendall line had reached its end. He lived in a house built for a family, rooms now packed with little but artifacts of a life already lived. He tended to spend time outside, where the world buzzed around him. One day, it strolled right up his front walk.

Terry's a tall fellow, friendly, open, gregarious. He took an instant liking to Clark, although, as he reflected later, the older man seemed a little lost. Sad. Lonely, "like he was ready to go."[479] They talked a while, and then Terry left. But he said he'd come back, and he did. He brought his wife, Judy, and their young daughter, Joy, who was maybe seven years old at the time. They became close, but it was Joy who sealed the deal when one Christmas she announced that their Clark wasn't just any old Clark—he was Grandpa Clark, a christening that pleased Kendall to no end.

He had a family now. He'd show them everything he owned and tell them the stories behind each item so that his memories would become theirs. They'd come to know his parents almost as well as he did (when they speak of Charles Kendall, they call him the familiar "Charlie"; Clark is "Grandpa" or, sometimes, "Gramps"). Eventually, they'd become legal heirs to his estate.

In exchange, they gave him hope. Kept him company. Saw to him when he fell ill. Took him to the fairgrounds to watch the horses, ushering him to a front-row spot so he could see them, right there, and he'd shed at least eighty years before their very eyes. And Judy—Judy fought like hell when she felt someone, or an institution under the auspices of anonymous someones—was testing his kindness or taking advantage of his age. Clark would often tell her, "You should have been an attorney," the fierce attorney he could never have been himself. They probably added another decade to his life.

Clark Kendall died on Sunday, June 4, 1989, a little more than three months before his eighty-sixth birthday. The *Albany Democrat-Herald* condensed his existence into 181 words and made no mention, beyond strict biography, of everything he'd endured.[480] He was the last adult link to the events of June 21, 1922. George Washington Manning, who was 41 when he and Harry DeAtley called for the coroner, cleared a full century and was closing in on 101 before he passed away in 1981.[481] Harry's wife, Myrtle, hung on twenty-

three years past her husband,[482] dying in 1979.[483] Roy Healy's widow, Ada, who later remarried, made it to 97 in 1985.[484]

In accordance with his final wishes, Clark Kendall was cremated. The Broughtons drove to the Oregon Coast, to the area where Clark said goodbye to Laverne in 1978, releasing her ashes into the Pacific Ocean. Now it was his turn. And so it was done.

Shortly after this ceremony, according to Judy, two seagulls descended from opposite directions to that very spot and then flew away together, their wings as shadows in the clear blue sky. She remains positive to this day that they witnessed Clark returning to his family at last. And with him left whatever animosity lingered for Dave West and the tragedy at Plainview.

"We forgive what happened," Judy said. "There's no sense carrying it on and on for generations. People snap. People do things. Nobody hates the man, in particular. It's been forgiven. You've got to do that to go on. What's all that hate going to accomplish?"[485]

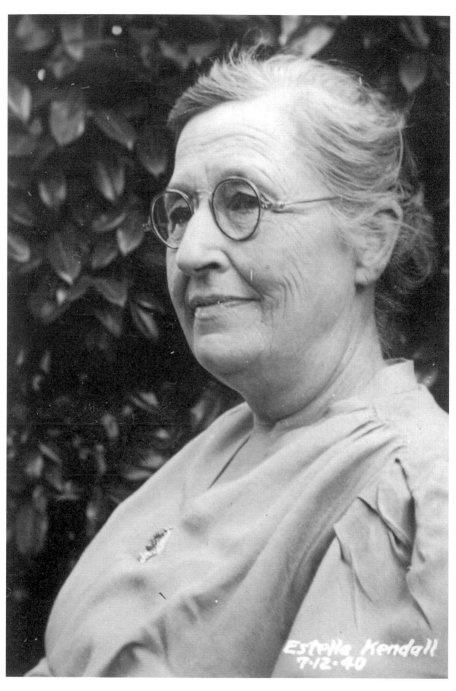

Estella Kendall in July 1940. *Courtesy of Judy and Terry Broughton.*

"The Dance of the Hours"

Came misty Dawn
Blue ribbons in her hair,
Floating among the lowlands.
Her shy and rosy sister, Morn,
Dancing along the hill-tops
Now bolder grows
As Day, in robes of gold,
Advances in the meadows.
She longer stays;
But comes the hour
When Eve, in purplish garments,
Steals softly 'mong the trees.
Her moment swiftly goes
To make way for Night,
Approaching in her festal black,
Adorned with starry diamonds
And silver crescent at her breast.

—Estella Kendall, February 25, 1939

Notes

The Minister

1. Reverend D.V. Poling, "A Prayer for 1922—A New Year Meditation," *Sunday Democrat*, January 1, 1922.
2. Ibid.
3. *Albany Democrat*, "Church Membership Is High During Year," January 2, 1922.
4. Family Group Sheets prepared by Ada Sidwell Healy Davidson, Gertrude Congdon Healy and Grace Sidwell Skinner, courtesy of Carla Healy.
5. Emma Simons Healy: Find-a-Grave Memorial, http://www.findagrave. com/cgi-bin/fg.cgi?page=gr&GSln=Healy&GSfn=Emma&GSbyrel=all&GSdyrel=all&GSob=n&GRid=30938392&df=all&.
6. 1900 United States Federal Census.
7. Oscar Healy: Find-a-Grave Memorial, http://www.findagrave.com/cgi-bin/fg.cgi?page=gr&GRid=30938328.
8. Social Security Death Index, Oregon Death Index (1898–2008).
9. "Death Takes Leonard B. Healy, Civic Leader" and J. Bruce Polwarth, "Tribute to Leonard B. Healy," from undated/unidentified newspaper article provided by Carla Healy.
10. 1910 United States Federal Census.
11. Family Group Sheets, courtesy of Carla Healy.
12. *(Eugene, OR) Register-Guard*, "Robert Sidwell Dies at Age of 85 Years," May 9, 1941.
13. Family Group Sheets, courtesy of Carla Healy.
14. *Eugene Daily Guard*, June 20, 1911.
15. *Eugene City Directory*, 1914.

16. American Christian Missionary Society, *The American Home Missionary*, vol. 20 (n.p., January 1914).

17. C.F. Swander, BA, MA, State Secretary Oregon Christian Missionary Convention, *Making Disciples in Oregon* (n.p.: C.F. Swander, 1928), 150, 243.

18. Unidentified 1922 church newspaper, photocopied by Ada Davidson on July 7, 1967.

19. *Lebanon Express*, "Slain Minister Was a Native of Lebanon Section," June 28, 1922.

20. World War I Draft Registration Cards, 1917–1918.

21. City of Zillah, "Heart of Wine Country, http://www.cityofzillah.us.

22. Family Group Sheets, courtesy of Carla Healy.

23. *California R.L. Polk and Co.'s Chico, Oroville and Gridley Directory* (1920).

24. City of Gridley, "A Small Town That Loves Company," http://www.gridley.ca.us.

25. *Albany Evening Herald*, "New Pastor at First Christian Church Spent Boyhood on Farm in Lebanon," September 11, 1920.

26. Poling, "Prayer for 1922."

THE SHERIFF

27. Martha Steinbacher, *Sweet Home in Linn County: New Life, New Land* (Charleston, SC: Arcadia Publishing, 2002), 93.

28. Doris Doherty and Bonnie Orr, *Ah, Yes…I Remember It Well* (Albany, OR: Albany Chamber of Commerce, 1976).

29. Woman's Christian Temperance Union, www.wctu.org.

30. Ibid.

31. Lucia H. Faxon Additon, *Twenty Eventful Years of Oregon Woman's Christian Temperance, 1880–1900* (Portland, OR: Gotshall Printing Company, 1904), 45.

32. Anti-Saloon League Museum, http://www.wpl.lib.oh.us/AntiSaloon/pmaterial.

33. Ibid.

34. *American Patriot*, May 1912.

35. F.G. Franklin, "The Temperance Movement," *Oregon Teachers' Monthly*, September 1915, 28.

36. Doherty and Orr, *Ah, Yes*.

37. *Albany Daily Democrat*, "Coffin Contains Shipment of Liquor," January 31, 1919.

38. Ibid., "Whiskey Flows in Albany Sewers," January 2, 1919.

39. Steinbacher, *Sweet Home*, 93.

40. Election results, *Albany Daily Democrat*, November 6, 1918.

41. *Albany Democrat*, "Linn's Martyred Sheriff Will Be Buried Saturday," June 24, 1922.

42. 1880 U.S. Federal Census.

43. Wedding announcement, courtesy of the Kendall Family Archives.

44. Correspondence from H.H.M. Cochran (Chalfants, Ohio) to Professor C.M. Kendall (Iowa, Kansas), July 7, 1901.

45. Estella Kendall's handwritten account of Clark's early life, courtesy of the Kendall Family Archives.

46. Ibid.

47. Ibid.

48. Ibid.

49 Letter: C.M. Kendall (Albany, Oregon), "Prefers a Heavy Revolver," *Recreation* 24–25 (January 1906): 70.

50. 1910–13 Albany City Directories.

51. Ibid.

52. Advertisement, *Milton Eagle*, April 7, 1911.

53. Correspondence from Frank Cooper to Professor C.M. Kendall, February 3, 1907.

54. Correspondence from L.R. Alderman to Professor C.M. Kendall, March 20, 1911.

55. Advertisement, *Milton Eagle*.

56. Oregon State Police History, http://www.oregon.gov/OSP/history.shtml.

57. Interview with Judy and Terry Broughton, January 12, 2013.

58. Interview with Art Martinak, Summer 2012.

59. *Albany Daily Democrat*, "Official Count in Linn County Finished Today," November 6, 1920.

60. Steinbacher, *Sweet Home*, 93.

61. *Albany Democrat*, "Attempt to Rob 2 Albany Homes," April 6, 1922.

62. Ibid., "Etiquette for Hoboes Taught by Police Chief," March 16, 1922.

JANUARY 1922

63. *Albany Democrat* (weekly edition), "Beebe Star Witness in Own Defense; All Testimony Finished," December 29, 1921.

64. Ibid., "Trial of Pete Beebe on Murder Charge Begun in Local Court," December 22, 1921.

65. *Lebanon Express*, "Murder Trial Is Set for Dec. 19," December 7, 1921.

66. Carson Douglas Beebe, Draft Registration Card, 1917–1918.

67. *Semi-Weekly Democrat*, "Lacomb Farmer and Son Murdered; Man Held as Suspect," November 3, 1921.

68. *Sunday Oregonian*, "Life of Pete Beebe, Suspected Slayer, Devoid of School Days and Social Joys," November 6, 1921.

69. *Evening Herald* article, date unknown.

70. *Lebanon Express*, "Father and Son Slain; Bodies in One Grave," November 2, 1921.
71. "Protesting His Innocence, Beebe Hears Charge Read, Sobs; Held Over to Grand Jury Without Bail," undated/unidentified clipping.
72. *Lebanon Criterion*, "Murdered Men Found Buried Near Their Home," November 4, 1921.
73. *Albany Democrat*, "First Witnesses in Beebe Trial Called; Plans Told to Jury," December 22, 1921
74. Ibid.
75. Ibid.
76. Ibid.
77. "Man Held for Death of 2 Men," undated/unidentified clipping.
78. *Semi-Weekly Democrat*, "Lacomb Farmer and Son Murdered; Man Held as Suspect," November 3, 1921.
79. *Albany Democrat* (weekly edition), "Beebe Star Witness in Own Defense; All Testimony Finished," December 29, 1921.
80. Mrs. John Bem's first name verified as Gladys Bem, 1920 U.S. Federal Census.
81. *Albany Democrat* (weekly edition), "Trial of Pete Beebe on Murder Charge Begun in Local Court," December 22, 1921.
82. *Evening Herald* article, date unknown.
83. Everett C. Fisher's coroner's report, November 1, 1921, Oregon State Historical Records.
84. *Lebanon Express*, "Father and Son Slain; Bodies in One Grave," November 2, 1921.
85. *Lebanon Criterion*. "Murdered Men Found."
86. "Parents of Man Held for Death of Pair Arrive," undated/unidentified clipping.
87. "Protesting His Innocence, Beebe Hears Charge Read, Sobs; Held Over to Grand Jury Without Bail," undated/unidentified clipping.
88. Ibid.
89. Ibid.
90. *Lebanon Express*, "Beebe Alone in Double Murder," November 9, 1921.
91. *Sunday Oregonian*, "Carson Douglas Beebe Has Lived Two Years in Wonder," November 20, 1921.
92. *The State of Oregon v. Carson D. Beebe.*
93. *Lebanon Express*, "Murder Trial Is Set for Dec. 19," December 7, 1921.
94. *The State of Oregon v. Carson D. Beebe.*
95. Ibid.
96. Ibid.
97. *Albany Democrat*. "First Witnesses in Beebe Trial Called."
98. Ibid.

99. Ibid.

100. Ibid., "Beebe Star Witness in Own Defense."

101. Ibid.

102. Ibid.

103. Ibid.

104. *Semi-Weekly Democrat* "Beebe Trial at End; Defense Eloquent in Pleas for Acquittal," December 29, 1921.

105. Ibid.

106. "More Instructions Are Asked at 3:30; Verdict Returned Late Today," undated/unidentified clipping.

107. Ibid.

108. *The State of Oregon v. Carson D. Beebe.*

109. "Indictment Against Beebe on Charge of Lad's Murder Hangs," undated/unidentified clipping.

110. *Albany Daily Democrat,* Chapel Service at Albany College Is Held This Morning," January 4, 1922.

111. Ibid., "Church News: First Christian Church," January 7, 1922.

112. Ibid., "300 Local People Pay Tribute to One Who Led Community," January 26, 1922.

113. *Albany Democrat,* "Sweet Home Farmer Weds School Teacher," January 30, 1922,

114. *Albany Daily Democrat,* "Attempt Again to Form 'Klan,'" January 27, 1922.

115. Ibid., "Man Wanted for Not Supporting His Wife Is Taken to Portland," January 27, 1922.

FEBRUARY

116. *Sunday Democrat,* "Look, Girls! Fatty 'Arbuckle' Was in Albany! Just Think of It," October 30, 1921.

117. Howard Chua-Eoan, "Crimes of the Century: The Fatty Arbuckle Scandal, 1920," *Time,* March 1, 2007, http://content.time.com/time/specials/packages/article/0,28804,1937349_1937350_1937366,00.html.

118. *Albany Democrat,* "Eddie La Montagne to Try to Sign 'Fatty' Arbuckle in Feature," February 2, 1922.

119. *San Francisco Examiner,* "Jurors Write Exoneration," April 13, 1922.

120. Stuart Oderman, *Roscoe "Fatty" Arbuckle: A Biography of the Silent Film Comedian, 1887–1933* (Jefferson, NC: McFarland & Company, 2005), 212.

121. William J. Mann, *Tinseltown: Murder, Morphine, and Madness at the Dawn of Hollywood* (New York: HarperCollins Publishers, 2014), 7.

122. *Albany Democrat*, "Alice in Hungerland" notice, February 18, 1922.

123. Ibid., "Editorial: Hollywood Mentality," February 21, 1922.

124. Ibid., "Mike Kulagan Fined $200 for Making of Intoxicating Booze," February 8, 1922; "Owns Whiskey, Is Sent to Jail," February 21, 1922.

125. Ibid., "No More Excuses for Lack of Auto Licenses," February 10, 1922.

126. Ibid., "Returns from Eugene" item re: Mrs. Roy Healy, February 10, 1922.

127. *Sunday Democrat*, "Dog Owners Will Interest Sheriff," February 12, 1922.

128. Ibid., "Sheriff Orders Pool Hall Man to Appear," February 12, 1922.

129. *Albany Democrat*, "Pool Hall Man Pays $25 for Letting Minors Play," February 14, 1922.

130. Ibid., item re: Richi's departure, February 27, 1922.

131. Ibid., "Bank Cashier Is Victim of Deadly Illness Attack," March 4, 1922.

132. Ibid., "Anthrax Carried on Shaving Brush Kills Albany Minister," February 24, 1922.

MARCH

133. *Albany Democrat*, "Albany for First Time Is Hostess to Real Motion Picture Actress," March 17, 1922.

134. Frank Gunning Wyatt and William Morris, *Mrs. Temple's Telegram: A Farce in Three Acts* (New York: Samuel French, 1908), 137.

135. *Mrs. Temple's Telegram*, Internet Movie Database, http://imdb.com/rg/an_share/title/title/tt0011486.

136. *Albany Democrat*, "Dr. Poling Assumes Responsibility for Smoking in Comedy," March 2, 1922.

137. Ibid.

138. Gunning and Wyatt, *Mrs. Temple's Telegram*, 5.

139. Ibid., 43.

140. *Albany Democrat*. "Dr. Poling Assumes Responsibility."

141. Ibid., "Bank Cashier Is Victim of Deadly Illness Attack," March 4, 1922.

142. Ibid., "Albany's Banks to Close in Deference to Ralph McKechnie," March 6, 1922.

143. Ibid., "Funeral Is Held for Ralph McKechnie Amid Crowds of Mourners," March 7, 1922.

144. Ibid., "Albany Woman, First Drawn on Jury, Accepted," March 6, 1922.

145. Ibid., "Two Jurors Excused But Trial Continues," March 8, 1922.

146. Ibid., "Woman Foreman of Jury in Linn for First Time," March 9, 1922.

147. *The State of Oregon v. Carson D. Beebe*.

148. *Albany Democrat*, "Attorneys on Both Sides Claim Beebe's Confession Untrue," March 10, 1922.

149. Ibid.

150. Ibid.

151. Ibid.

152. *Oregon State Board of Health Certificate of Death for Carson D. Beebe*, May 29, 1927.

153. "Honoring the Past – List of Unclaimed Cremains," Oregon State Hospital, www.oregon.gov/oha/osh/Pages/cremains.aspx.

154. *Albany Democrat*, "Officials Fear 'Flu' Epidemic in County Jail," March 15, 1922.

155. Ibid., "Prisoner Is Better," March 16, 1922.

156. Ibid., "Rev. Healy Returns," March 17, 1922.

157. Ibid., "Albany for First Time Is Hostess to Real Motion Picture Actress," March 17, 1922.

158. *Australian Dictionary of Biography*, vol. 10 (n.p.: MUP, 1986), http://adb.anu.edu.au/lovely-louise-ncllic-7248.

159. Women Film Pioneers Project: "Profile–Louise Lovely, https://wfpp.cdrs.columbia.edu/pioneer/ccp-louise-lovely.

160. Australia's Silent Film Festival Hall of Fame: Louise Lovely, http://www.ozsilentfilmfestival.com.au/fame/index.asp?IntCatId=35&IntContId=58.

161. *Albany Democrat*. "Albany for First Time."

162. Ibid.

163. Multiple pages of advertisements, *Albany Democrat*, March 17, 1922.

April

164. *Morning Oregonian*, "Hecker, Alleged Slayer, Is Favored Prisoner," April 20, 1922.

165. *Albany Democrat*, "Albany Boy Murderer," April 18, 1922.

166. The location of the bridge where Russell Hecker disposed of Frank Bowker's body was determined using an artist's rendering of the crime scene from the April 21, 1922 *Albany Democrat*, a 1938 Metzker map of the area and Google Maps.

167. 1910 U.S. Federal Census.

168. 1880 and 1900 U.S. Federal Census.

169. *Albany Democrat*, "Albany Boy Murderer,"

170. Ibid.

171. *Morning Oregonian*, "Hecker Defense Still Mystery," June 29, 1922.

172. *Albany Democrat*, "Bowker's Body Positively Identified," April 21, 1922

173. Ibid., "'Mother's Boy' Is Estimate Given by Hecker's Lover," April 19, 1922.

174. Ibid."

175. *Morning Oregonian*, "Girl Out on Bail After Murder Quiz," April 20, 1922.
176. *Albany Democrat*, "Albany Boy Murderer."
177. *Morning Oregonian*, "3 Firms Incorporated," April 1, 1922.
178. Ibid., "Johnson & Hecker, sales agents" classified ad, March 19, 1922.
179. *Albany Democrat*, "Albany Boy Murderer."
180. Ibid.
181. Ibid.
182. Ibid.
183. *Morning Oregonian*, "Musician Slain; Youth Confesses," April 18, 1922.
184. *Albany Democrat*, "Albany Boy Murderer."
185. Ibid.
186. Ibid.
187. *Albany Democrat*, "Complexity of Hecker Case Is Only Increased by Revelation Made by Local Killing Suspect," April 19, 1922.
188. *Albany Democrat*, "Complexity of Hecker Case."
189. Ibid.
190. Ibid., "Bowker Murder Still a Mystery; Finding of Moncy Affords Clue; Local People Grilled by Police," April 20, 1922.
191. Ibid., "'Mother's Boy' Is Estimate Given by Hecker's Lover," April 19, 1922.
192. Ibid., "Complexity of Hecker Case."
193. Ibid., "Bowker Murder Still a Mystery."
194. Ibid.
195. *Morning Oregonian*, "Hecker, Alleged Slayer, Is Favored Prisoner,"
196. *Albany Democrat*, "Bowker's Body Positively Identified."
197. Ibid.
198. Ibid.
199. Ibid., "Hecker's Trial Will Be Held in Portland, Word," April 22, 1922.
200. *Sunday Democrat*, "Arraignment of Hecker May Not Come for Weeks," April 23, 1922.
201. *Albany Democrat*, "Hecker's Trial Will Be Held in Portland."
202. Ibid., "Gunshot Calls Linn Sheriff," April 29, 1922.
203. *Sunday Democrat*, "Blood Pool May Mean Tragedy," April 30, 1922.

MAY

204. *Brownsville Times*, "Ku Klux Klan Invades This City," May 12, 1922.
205. *Albany Democrat*, "Woman Jurors Highly Praised," May 3, 1922.
206. Ibid., "Woman in Buick Is New Record Holder in 724-Mile Journey," May 4, 1922. (*Note*: Ayers's name was misspelled in the *Democrat* article. The correct spelling was verified via the *San Francisco Chronicle*, February 27, 1921.)

207. Ibid., "Waffle Supper Tonight," May 2, 1922.
208. Ibid., "Woman in Buick Is New Record Holder in 724-Mile Journey."
209. Ibid., "Albany Has 10.1 Miles of Paving," May 9, 1922. (Albany's size is described by using a 1925 city map, courtesy of the Albany Regional Museum.)
210. Ibid., "East Albany in Midst of Boom," May 2, 1922.
211. Ibid., "New Oil Station," 15, 1922.
212. Address for the Cottage Hotel (more commonly called "The Cottage"), *Linn, Benton and Lincoln Counties Telephone Directory*, August 1914; same as address for the Bridgewater Hospital, *Linn, Benton and Lincoln Counties Telephone Directory*, December 1927.
213. *Albany Democrat*, "New Hospital Opens Monday," May 27, 1922.
214. Ibid., "1922 Graduating Class at Albany High School Includes 50," May 3, 1922.
215. Ibid., "Klan's Pictures Draw Big Crowd," Friday, April 21, 1922.
216. Ibid.
217. Ibid., "K.C. Members Offers $500 to K.K.K. If Charges Are Proved True," April 21, 1922.
218. Advertisement: "Attention Ku Klux Klan," *Albany Democrat*, April 21, 1922.
219. *Albany Democrat*, "Klan's Charges Flatly Denied," May 9, 1922.
220. Advertisement: First Presbyterian Minstrels, *Albany Democrat*, May 6, 1922.
221. *Albany Democrat*, "Success Marks Minstrel Show, College Benefit," May 11, 1922.
222. Ibid.
223. Laura Alton Payne, "Youth," as entered into Charles M. Kendall's journal.
224. *Brownsville Times*, "Form Citizenship League," May 12, 1922.
225. Ibid., "Ku Klux Klan Invades This City," May 12, 1922.
226. Ibid., "Want Teachers Who Do Not Dance," May 19, 1922.
227. Ibid.
228. *Albany Democrat*, "Ban on School Teachers Who Dance Planned," May 19, 1922.
229. *Brownsville Times*, "New League to Hold Public Meeting," June 9, 1922.
230. *Albany Democrat*, "Still Owner of Mill City Taken," May 24, 1922.
231. Ibid., "Students Told to Choose Well Future Course," May 29, 1922.
232. Ibid., "Fire Menaces Bridge Again But Harm Curtailed," May 30, 1922.

JUNE 1-20

233. *Albany Democrat*, "Oakville Man Is Now in Jail on Serious Charge," June 5, 1922.
234. *Sunday Democrat*, "Albany's Beautiful Gardens," June 4, 1922.

235. Calavan's Drug Store location taken from advertisement in the Albany High School *Whirlwind* (yearbook), June 1920.

236. *Albany Democrat*, "Oakville Man Is Now in Jail."

237. Ibid.

238. C.A. Sloat's full name: Cloy Alvin Sloat, *Sunset Valley: A Romance of the Oregon Country* (New York: Comet Press Books, 1957).

239. *Albany Democrat*, "Oakville Man Is Now in Jail."

240. Ibid., "Previous Charge of Immorality Admitted by Sloat, Report," June 6, 1922.

241. Ibid., "Charges Piling Up on C.A. Sloat," June 12, 1922.

242. Ibid., "Sloat Served in Jail at Tacoma," June 14, 1922.

243. Ibid., "Sloat Admits He Is Guilty of All Crimes Charged," June 13, 1922.

244. Highlights from Sheriff Kendall and District Attorney Lewelling's meeting with the Good Citizenship League, *Brownsville Times*, June 16, 1922.

245. *Albany Democrat*, "Sloat Admits He Is Guilty of All Crimes Charged," June 13, 1922.

246. Ibid., "Sloat Indicted on Six Counts," June 20, 1922.

June 21 (Prelude)

247. *Albany Democrat* (early edition), "Linn County Is Heaven's Rival, McDaniel Says," June 21, 1922

248. Ibid., "Gruesome Find Made by Sailor Body Searches," June 21, 1922.

249. Ibid., "Take Sloat to Hear Sentence," June 21, 1922.

250. Ibid., "Linn County Is Heaven's Rival."

The Farmer

251. *Albany Democrat*, "Editorials of the People: Old Hunter Speaks," January 2, 1922.

252. Ibid., "Old Hunter Speaks."

253. E-mail verification re: *Dave West v. Burghduff* (case #11628) from the Linn County Courthouse Circuit Court Copy Center, October 17, 2012.

254. *Albany Democrat*, "Wife of Slayer Suicide Details Story of Killing," June 23, 1922.

255. Ibid.

256. Allen Parker telephone interview, November 2012.

257. Land Deed #18720 filed April 29, 1911, *Linn County, Oregon, Index to Deeds-Direct (A-F)*, Linn County 5, vol. 95, 268.

258. Thomas Ward info: John Miles and Richard R. Milligan, comps., *Linn Co. Or. D.L.C. (Donation Land Claim)*, vols. 11–15 (n.p., 1989), 74.

259. WPA interview: Bonar, Anna (Ward), June 9, 1940.

260. West home descriptions from diagrams accompanying *Albany Democrat*, "Linn Tragedy Sidelights Penned by Charles Alexander, Albany Writer," June 22, 1922; Fred Lockley, "Lockley Describes Scene of Plainview Murders," *Sunday Democrat*, June 25, 1922; and Allen Parker telephone interview.

261. *Indiana, Marriage Collection, 1880–1941.*

262. Richard W. Helbock, *Oregon Post Offices, 1847–1982* (Las Cruces, NM, 1982), 79.

263. Floyd C. Mullen, *The Land of Linn: An Historical Account of Linn County, Oregon* (Lebanon, OR: Dalton's Printing, 1971), 68.

264. Allen Parker telephone interview.

JUNE 21 (AFTERNOON)

265. *Brownsville Times*, "3 Dead as Result of Raid on Still," June 23, 1922.

266. *Albany Democrat*, "Community Grieves for Martyrs," June 22, 1922.

267. Directions/distance to the Dave West property determined using Google Maps. The lady and I actually drove Sheriff Kendall's likely route on Friday, April 4, 2014.

268. Mrs. DeAtley's first name: 1930 U.S. Federal Census.

269. Obituary for Argyol Glenn "Tom" DeAtley, *Idaho Statesman*, March 17, 2006.

270. *Sunday Democrat*, "Lockley Describes Scene of Plainview Murders."

271. *Brownsville Times*, "3 Dead as Result of Raid on Still."

272. Ibid.

273. Ibid.

274. *Albany Democrat*, "Community Grieves for Martyrs."

275. Ibid., "Linn Tragedy Sidelights Penned by Charles Alexander."

276. Ibid., "Wife of Slayer Suicide Details Story of Killing," June 23, 1922.

277. Ibid.

JUNE 21 (THE AFTERMATH)

278. *Brownsville Times*, "3 Dead as Result of Raid on Still."

279. Wendell Manning interview, 2013.

280. *Albany Democrat* (extra edition), "Sheriff and Minister Die," June 21, 1922.

281. *Brownsville Times*, "3 Dead as Result of Raid on Still."

282. Ibid.

283. Ibid.

284. *Albany Democrat*, "Wife of Slayer Suicide Details Story of Killing," June 23, 1922.

285. *Sunday Democrat*, "Lockley Describes Scene of Plainview Murders."

286. *Albany Democrat*, "Wife of Slayer Suicide Details Story of Killing."

287. Ibid., "Community Grieves for Martyrs."

288. Ibid., "Linn Tragedy Sidelights Penned by Charles Alexander, Albany Writer."

289. Ibid., "Sheriff and Minister Die."

290. Ibid.

291. Wendell Manning interview, 2013.

292. *Albany Democrat*, "Community Grieves for Martyrs."

293. *Sunday Democrat*, "Lockley Describes Scene of Plainview Murders."

294. Ibid.

295. *Albany Democrat*, "Linn Tragedy Sidelights Penned by Charles Alexander, Albany Writer."

296. *Sunday Democrat*, "Lockley Describes Scene of Plainview Murders," June 25, 1922.

297. *Albany Democrat*, "19-Year-Old Boy Bravest of All Plainview Posse," June 22, 1922.

298. Ibid.

299. *Sunday Democrat*, "Lockley Describes Scene of Plainview Murders."

300. *Albany Democrat*, "19-Year-Old Boy Bravest of All Plainview Posse."

301. *Sunday Democrat*, "Lockley Describes Scene of Plainview Murders."

302. *Albany Democrat*, "Linn Tragedy Sidelights Penned by Charles Alexander."

303. Ibid., "19-Year-Old Boy Bravest of All Plainview Posse."

REST IN PEACE

304. *Sunday Democrat*, "Throngs Attend Last Rites for Slain Official," June 25, 1922.

305. *Albany Democrat*, "Wife of Slayer Suicide Details Story of Killing."

306. Ibid., "Doubt That Dead Sheriff Ever Saw West Suggested," June 24, 1922.

307. *Capital Journal (Salem, OR)*, "Slayer of Kendall and Healy Known as Mean Man, Report," June 22, 1922.

308. Editorial, "Albany Mourns Again," *Albany Democrat*, June 22, 1922.

309. Dr. J.H. Robnett's Certificates of Examining Physician for Dave West, C.M. Kendall and Roy Healy, June 21, 1922, Oregon State Archives.

310. Everett Fisher's coroner's report, June 21, 1922, Oregon State Archives.

311. *Albany Democrat*, "Roy Healy to Be Buried in Eugene," June 22, 1922.

312. Eugene Pioneer Cemetery, Eugene, OR.

313. *Albany Democrat*, "Memorial for Healy Planned," June 23, 1922.

314. Ibid., "Wife of Slayer Suicide Details Story of Killing."

315. Sandridge Cemetery, Lebanon, OR.

316. "Last Will and Testament of D.F. West," signed June 23, 1906, and filed June 28, 1922; *Record of Wills 6, Linn County 1920–1930* (#134).

317. *Albany Democrat*, "Stores to Close in Deference to Sheriff Kendall," June 23, 1922.

318. *Sunday Democrat*, "Throngs Attend Last Rites for Slain Official" June 25, 1922.

319. Ibid.

320. Ibid.

A New Sheriff in Town

321. *Albany Democrat*, "Shedd Farmer Is Made Sheriff in Kendall's Stead," June 26, 1922.

322. Ibid., "Shedd Farmer Is Made Sheriff in Kendall's Stead."

323. *Oregonian* editorial excerpted in *OAC Alumnus* 1–2 (June 1923).

324. *Brownsville Times*, "Thousands Pay Respects to Dead Linn County Sheriff," May 25, 1923.

325. 1900 U.S. Federal Census.

326. "The Three Misses Dunlap Who Are Sisters, Have Bought the Crandall Drug Store," *NARD Journal* 29 (n.d.).

327. George Edmonston Jr., OSU Alumni Association, "Up Close and Personal: Greatest Games in the History of OSU Football," August 22, 2003, http://osubeavers.com/ViewArticle.dbml?DB_OEM_ID=30800&ATCLID=207814975.

328. Ibid.

329. *Albany Democrat*, "Linn County People Hear Law Enforcement Lessons from Story of Sheriff's Death," May 23, 1923.

330. Ibid., "Shedd Farmer Is Made Sheriff in Kendall's Stead."

The Fate of Russell Hecker

331. *Morning Oregonian*, "Hecker Admits Killing Bowker," July 1, 1922.

332. Ibid., "Hecker Defense Still Mystery."

333. Ibid., "Hecker on Stand in Murder Case," June 30, 1922.

334. Ibid., "Hecker Admits Killing Bowker."

335. *Oregon City Enterprise*, "Russell Hecker Found Guilty of Bowker Murder," July 7, 1922.

336. Ibid.

337. Ibid.

338. Ibid.

339. *Banner Courier (Oregon City, OR)*, "Murder in First Degree Verdict Is Returned," July 6, 1922.

340. Ibid.

341. *Oregon Daily Journal (Portland)*, "Court Order Stays Execution," August 8, 1922.

342. Editorial, "The Conviction of Hecker," *Morning Oregonian*, July 3, 1922.

343. *Morning Oregonian*, "Transfer to Penitentiary Made Last Night and Doomed Man Affable with Officers," July 6, 1922.

344. *Oregon City Enterprise*, "Russell Hecker Given Official Prison Garb," Friday, July 14, 1922.

345. *Evening Record (Ellensburg, WA)*, "Albany, Ore., Youth Hanged for Murder," September 22, 1922.

MAY 20, 1923 (AND ALL THAT FOLLOWED)

346. *Semi-Weekly Democrat (Albany, OR)*, "No Tears Will Be Shed in Linn Upon Death of Parker," August 30, 1923.

347. *Albany Evening Herald*, "Sheriff Dunlap Dies at 1:30," May 21, 1923.

348. Ibid.

349. *Albany Democrat*, "Sheriff Dunlap Is Dead."

350. Ibid., "Linn County Voters Confer Offices Upon Most of Democrats," November 16, 1922.

351. Ellsworth Lillard's police report (courtesy of the Linn County Sheriff's Office); Geraldine Hamilton identified in *Albany Evening Herald*, "Sheriff Dunlap Dies at 1:30."

352. *Albany Evening Herald*, "Sheriff Dunlap Dies at 1:30."

353. *Albany Democrat*, "Sheriff Dunlap Is Dead."

354. *Albany Evening Herald*, "Sheriff Dunlap Dies at 1:30."

355. Ibid.

356. Ibid.

357. Ellsworth Lillard's police report.

358. Ibid.

359. *Albany Democrat*, "Sheriff Dunlap Is Dead."

360. Ellsworth Lillard's police report.

361. *Albany Democrat*, "Sheriff Dunlap Is Dead."

362. *Albany Evening Herald*, "Sheriff Dunlap Dies at 1:30."

363. Ibid.

364. Ellsworth Lillard's police report.

365. *Albany Evening Herald*, "Sheriff Dunlap Dies at 1:30."

366. Ellsworth Lillard's police report.

367. Ibid.

368. *Albany Evening Herald*, "Sheriff Dunlap Dies at 1:30."

369. Ibid.

370. Ibid.

371. *Eugene Daily Guard*, "Murderer's Description Received," July 5, 1923.

372. U.S. World War I Draft Registration Cards, 1917–1918.

373. *Albany Evening Herald*, "Parker Is Silent on Life Story," May 25, 1923.

374. *Albany Democrat*, "Art Beckley Admits He Served Time; Is Identified as Bad Man; True Name Is Johnson, Claim," May 24, 1923.

375. *Albany Evening Herald*, "Rulie Johnson's Picture Sent by Colorado Warden," July 12, 1923.

376. Ibid., "Fate of Parker in Hands of Jury This Afternoon," July 19, 1923.

377. *Albany Evening Herald*, "Sheriff Dunlap Dies at 1:30."

378. *Sunday Democrat*, "Parker Seeks to Avoid Detection by Finger Prints," May 27, 1923.

379. *Eugene Daily Guard*, "Slayer of Sheriff Dunlap Is Identified," May 28, 1923.

380. *Albany Democrat*, "Art Beckley Admits He Served Time."

381. Ibid.

382. United Press item, "Man Who Killed Sheriff One of Two Bank Robbers at Wilsonville, Is Theory," *Bend Bulletin*, May 25, 1923.

383. *Albany Evening Herald*, "Geo. Parker May be Native of Northwest," May 26, 1923.

384. *Albany Democrat*, "Little by Little Clues Are Found to Unveil Crimes," May 26, 1923.

385. Ibid., "Johnson's Gun and Hat Found; Discredit Tale," May 25, 1923.

386. Ibid., "Art Beckley Admits He Served Time."

387. Ibid.

388. *Albany Evening Herald*, "Sheriff Dunlap Dies at 1:30."

389. *Corvallis Gazette-Times*, "Dunlap Funeral at Albany and Shedd Today," May 23, 1923.

390. *Albany Evening Herald*, "Sheriff Dunlap Dies at 1:30."

391. Ibid.

392. *Albany Evening Herald*, "Fate of Parker in Hands of Jury,"

393. Ibid., "Record of Beckley Is Discovered," May 24, 1923.

394. *Albany Democrat*, "Make Plans to Try Criminals; Albany Is Quiet," May 24, 1923.

395. Ibid., "Make Plans to Try Criminals."

396. *Corvallis Gazette-Times*, "Lebanon Man Made Sheriff of Linn," May 23, 1923.

397. Oregon State Sheriff's Association, *A History of the Oregon Sheriffs, 1841–1991*, http://gesswhoto.com/sheriff-linn.html.

398. *Albany Democrat-Herald*, "Frank Richard, Former Linn Sheriff, Dies," April 6, 1949.

399. Ibid., "Men Plead Not Guilty Today to 2 Charges," June 25, 1923.

400. *Albany Evening Herald*, "Rulie Johnson Is Still Free After Sensational Break," July 2, 1923.

401. *Semi-Weekly Democrat*, "No Tears Will Be Shed in Linn Upon Death of Parker."

402. *Albany Democrat*, "Outside Aid for Prisoners Held Highly Possible," July 2, 1923.

403. *Albany Evening Herald*, "Rulie Johnson Is Still Free After Sensational Break"; *Albany Democrat*, "Alleged Murderer of Former Sheriff Still at Large Today After Escape from Linn Jail," July 2, 1923.

404. *Albany Evening Herald*, "Rulie Johnson Is Still Free After Sensational Break."

405. Ibid.

406. *Albany Democrat*, "Wife Divorces Rulie Johnson," May 22, 1924.

407. *Semi-Weekly Democrat*, "Rulie Johnson's Wife Suing Him," March 20, 1924.

408. *Albany Democrat*, "Linn County Offer $500 Reward for Return of Escaped Alleged Murderer," July 2, 1923.

409. *Albany Evening Herald*, "Rulie Johnson Is Still Free After Sensational Break."

410. *Albany Democrat*, "Parker Will Hang Friday, Aug. 31, Judge Kelly Says," July 26, 1923.

411. *Albany Evening Herald*, "Jury List Completed for Trial," July 18, 1923.

412. Ibid., "Fate of Parker in Hands of Jury."

413. Ibid.

414. *Albany Democrat*, "Parker Is Guilty, Jurymen Declare; No Mercy Asked," July 19, 1923.

415. Ibid., "Actual Trial of George Parker Begins; Self Defense Is His Plea; Jury Is Completed Late Today," July 18, 1923.

416. *Albany Evening Herald*, "Fate of Parker in Hands of Jury."

417. Ibid.

418. *Morning Register (Eugene, OR)* "George Parker to Hang," July 20, 1923.

419. *Capital Journal (Salem, OR)*, "Eleventh Hour Reprieve Halts Parker Hanging," August 31, 1923.

420. *Semi-Weekly Democrat*, "No Tears Will Be Shed in Linn Upon Death of Parker."

421. *Albany Democrat*, "Parker's Death Is Postponed; Governor Grants Reprieve to Allow for Appeal Latest Word," August 30, 1923.

422. *Albany Evening Herald*, "George Parker Must Hang for Murder of Sheriff," December 19, 1923.

423. *Albany Democrat*, "George Parker Pays Penalty for Murdering Linn County Sheriff; Goes Unflinchingly to His End," January 4, 1924.

424. Ibid.

Russell Hecker's Luck Holds Out

425. Frederick L. Collins, "At Home with the Governors: Yes, This Is Walter," *Woman's Home Companion*, November 1924, 88.

426. *Oregon City Enterprise*, "Russell Hecker Asks New Trial of Murder Case," July 21, 1922.

427. Ibid.

428. *Banner-Courier*, "New Trial Is Denied Hecker by Judge Campbell," August 3, 1922.

429. Don Nelson, "Of Planes, Trains, Films and Farms," *Oregonian*, March 30, 2008.

430. *Morning Oregonian*, "Movie Taken in Jail," September 22, 1922.

431. *The Way of the Transgressor* (1923), Internet Movie Database, http://imdb.com/rg/an_share/title/title/tt0177360; *The Way of the Transgressor* (1923), Oregon Film Museum, http://beta.oregonfilmmuseum.com/movie/info/the-way-of-the-transgressor.html.

432. *Albany Democrat*, "Russell Hecker Must Hang, Says Supreme Court," December 20, 1923.

433. *Capital Journal*, "Russell Hecker to be Hanged May 21," February 27, 1924.

434. Collins, "Yes, This Is Walter," 88.

435. Ibid.

436. Ibid.

437. Ibid.

438. Ibid.

439. Ibid.

440. Ibid.

441. *Salem Statesman Journal*, "Prisoner Known Here," July 30, 1940

442. Washington, Marriage Records, 1865–2004.

443. 1940 United States Federal Census.

444. *Spokesman Review (Spokane, OR)*, "'Proceed Slowly' Order in Effect on Flooded Streets," July 27, 1940.

445. *Spokane Daily Chronicle (Washington, OR)*, "Taxi Driver Dies in Crash," July 27, 1940.

446. Ibid., "Hecker Charge Filed," July 29, 1940.

447. Ibid., "$5340 Damage Suit Is Started Today," January 22, 1942.

448. Ibid., "Hecker Allowed $635 in Damages," January 23, 1942.

449. Oregon, Death Index, 1898–2008.

The Resurrection of Cloy Alvin Sloat

450. *Capital Journal*, "Pervert to be Returned for Trial Here," June 13, 1922.

451. Ibid.

452. Ibid.

453. Ibid., "Sloat Is Sentenced to Prison for Life—Enters Plea of Guilty on Three Counts," June 22, 1922.

454. Ibid., "Mrs. Sarah Sloat Dies at a Hospital," October 24, 1924.

455. *Capital Journal*, "Locals" (column), October 27, 1924.

456. *Cannon v. Gladden*, Supreme Court of Oregon (argued March 3, 1955; reversed March 12, 1955; and opinion clarified: March 23, 1955), https://scholar.google.com/scholar_case?case=15567887136985646549&hl=en&as_sdt=6&as_vis=1&oi=scholarr.

457. Ibid.

458. Mentioned in *State of Oregon v. Collis*, Supreme Court Decisions (argued January 31, 1966; affirmed as modified March 30, 1966): "In March of 1955 this court, in *Cannon v. Gladden*, 203 Or 629.281 P2d 23, held that a life sentence under ORS 163.270 for the crime of attempted rape was unconstitutionally disproportionate because the completed act of rape was punishable by a maximum of 20 years. Because of the *Cannon v. Gladden* decision, the legislature, which was then in session, amended the punishment provisions of ORS 163.270 by Oregon Laws 1955, ch 371," http://law.justia.com/cases/oregon/supreme-court/1966/243-or-222-3.html.

459. *Capital Journal*, "Jefferson Man Goes to Court to Keep from Going to Prison," November 26, 1956.

460. Ibid.

461. Ibid.

462. *Albany Democrat-Herald*, "Ex-Convict Wins Fight for Freedom," December 12, 1956.

463. Sloat, *Sunset Valley*.

464. Ibid., 84.

465. Charles Alexander, "Book Briefs and Best Sellers," *Albany Democrat-Herald*, January 4, 1958.

466. Ibid., May 24, 1958.

EPILOGUE

467. Interview with Judy and Terry Broughton.

468. Notes for Clark Kendall's "My Memories of Albany."

469. Interview with Judy and Terry Broughton.

470. Calendar Showing Complete Record and Final Disposition of All Bills by Oregon Legislative Assembly, Chapter 197, "Oregon Laws and Resolutions," February 24, 1923.

471. *Deed Record* 124 (July 29, 1922): 391.

472. Oregon, Death Index, 1892–2008.

473. Estella Kendall death notice, *Albany Democrat-Herald*, October 3, 1963.

474. Wallace Eakin, "Linn's Greatest Tragedy," *Albany Democrat-Herald*, October 7, 1963.

475. Clark Kendall obituary, *Albany Democrat-Herald*, June 6, 1989; Laverne Kendall obituary, *Albany Democrat-Herald*, September 23, 1978.

476. Clark Kendall obituary, *Albany Democrat-Herald*.

477. Laverne Kendall obituary, *Albany Democrat-Herald*.

478. Clark Kendall obituary, *Albany Democrat-Herald*.

479. Interview with Judy and Terry Broughton.

480. Clark Kendall obituary, *Albany Democrat-Herald*.

481. U.S. Social Security Death Index, 1935–2014.

482. Myrtle Deatley, Findagrave.com, http://www.findagrave.com/cgi-bin/fg.cgi?page=gr&GSfn=Myrtle&GSbyrel=all&GSdyrel=all&GSob=n&GRid=21576864&df=all&.

483. Oregon State Library; 1966–1970 Death Index, Reel Title: State of Oregon Death Index, Year Range: 1971–1980.

484. U.S. Social Security Death Index, 1935–2014.

485. Interview with Judy and Terry Broughton.

ABOUT THE AUTHOR

Cory Frye is a multiple-award-winning writer and editor based in Oregon's lush, mushy Willamette Valley. His work has appeared in the *Albany Democrat-Herald*, *Corvallis Gazette-Times*, *Oregonian*, *Under the Radar*, *Stereo Subversion*, Yahoo! Music, iTunes and the Rock and Roll Hall of Fame. In a previous life, he was an editor and occasional producer for Rhino Entertainment, a subsidiary of Warner Music Group, and thus in part responsible for the critically drubbed 7-CD *Whatever: The '90s Pop & Culture Box* (2005) and the more respectable Afghan Whigs career compendium, *Unbreakable: A Retrospective* (2007). He loves music and history and is forever game to write about either or both.